"I love *10-Mile Radius*! A multilayered conversation about awareness, it's surprising in its honesty, beautiful in its artistry, serious, funny, and tender all at once. Gwynn's book is proof positive that, though we grow ill, or old, or diminish in a variety of ways, we don't have to be diminished ourselves. Forced to slow down, we focus, we pay attention, and we discover the infinite in a grain of sand—or within a ten-mile radius of home."

—Janet Fitch, author of *White Oleander, Paint it Black*, and *The Revolution of Marina M.*

"Opening Cat Gwynn's *10-Mile Radius,* I soon had my own favorite images. But by the last page it was the magnificent yet clean gesture of the entire collection that made me think, *O, help me learn to see the world this way!*"

—Mary Rakow, author of *This is Why I Came,* a novel

"As Cat painstakingly persevered though surgeries, debilitating treatments, and recovery, how easy it could have been to close down and give in to the allures of self-numbing or self-pity. Instead she chose to embrace the ordeal, leveraging her aesthetic skills and a profound spiritual acceptance to transform the confined spaces of her experience into page after page of emotionally resonant images."

—Josh Korda, author of *Unsubscribe,* Buddhist mentor and guiding teacher at NYC Dharma Punx

"*10-Mile Radius* provides an exceptional template for finding meaning in the face of profound uncertainty. The book inspires through photographs and text to appreciate small moments, traces of humanity, and elegance in the ordinary through Cat's remarkable eyes."

—Aline Smithson, photographer, founder and editor of *Lenscratch,* a daily journal of contemporary photography

"Forget about tragic and happy endings, this is not a book about how the story ends, it is a book about how the story is told. And the photographs? They take my breath away. Reading *10-Mile Radius* feels like winning a spiritual lottery.

—Janina Frankel-Yoeli, writer, Arab-Israeli peace activist, and contributor to *The Times of Israel*

"What a spectacular work combining magnificent photos with heart-expanding text!"

—Dorothy Dai-En Friedman, sensei at Ocean Zendo and the New York Zen Center for Contemplative Care

"I opened *10-Mile Radius* thinking I would learn about an experience with cancer. How wrong. What I found was the magic of the present moment. Words and images weave together to tell many stories, which all lead back to one simple idea: light and darkness are a pair. Whether she meant to or not, Cat Gwynn does nothing less than show us a path to a meaningful life."

—Samantha Dunn, author of *Not By Accident: Reconstructing a Careless Life*

"*10-Mile Radius* shows us all how to see with our hearts. Cat teaches us that witnessing life is the same as loving it, no matter what it presents to us. This gorgeous book is a primer to remind us that beauty is always available in every moment."

—Kelly Carlin, performer and author of *A Carlin Home Companion*: *Growing Up with George*

"The role of the artist is to chronicle, witness, interpret, and communicate. Gwynn turns a mirror to the viewer with every photograph. Where some see darkness, the work conveys hope, potential, renewal, and strength, while revealing the long and arduous road traveled to get there."

—Paula Tognarelli, executive director and curator, Griffin Museum of Photography

"In *10-Mile Radius*, Cat Gwynn invites us to join her on an artist's journey of discovery through cancer—a journey she chose to accept as a profound affirmation of life and love. Cat's photographic memoir of what she saw and felt on her way to healing reminds us that, whatever our restrictions, art sets us free and connects us to all life everywhere. Within Cat's *10-Mile Radius*, fear becomes hope, sorrow becomes joy, and heart becomes soul."

—Anne Stockwell, author, activist, and founder of *Well Again Beyond Cancer*

"As a breast cancer survivor myself, and also part of Cat's health care team, I appreciate her willingness to look deeply within, all the while opening her eyes and heart to the world around her as a healthy way to interpret the unknown. A must-read for those who seek to understand the art of healing."

—Sherry Goldman, nurse practitioner at Saul and Joyce Brandman Breast Center, Cedars-Sinai

"Explored through heartfelt, unapologetic prose, this inspiring chronicle of hope, honesty, and possibility is viewed through an exquisite series of photos taken within a ten-mile radius of where her cancer story unfolds. A fine-spun record of one woman's flowering spirit and the pursuit of meaning and healing through the fusion of language and art."

—David Francis, author of *Stray Dog Winter* and *Wedding Bush Road*

"The line leading into Cat Gwynn's remarkable *10-Mile Radius*, 'The urgency of life becomes a beautifully sharp lens,' sets a poetic tone for this superb, unique symphony of both words and images. Speaking and shooting from within the belly of the beast, but able to step outside her personal narrative to speak of universal emotions with a clear lens and a clear pen, Gwynn has given us a gift for the ages: an original voice and an original eye, combining to take us on a very original—and thought-provoking—journey."

—Peter Richmond, author of *The Glory Game*, *My Father's War,* and *Badasses*

"Cat Gwynn's glorious book shows us how to passionately and deeply love a world in which pain is a part."

—Kris Carr, bestselling author, wellness advocate, and cancer thriver

"The Buddha encouraged present-time awareness and clear comprehension of all phenomena, both internal and external. In *10-Mile Radius*, Cat Gwynn shares her deep and clear views on the immensity of being, the density of existence, the stages of decay, and the incredible light of Los Angeles. This book is a meditation. Enjoy."

—Noah Levine, bestselling author, Buddhist teacher and founder of Against The Stream and Refuge Recovery Centers

10-MILE RADIUS

10-MILE RADIUS

Reframing Life On the Path Through Cancer

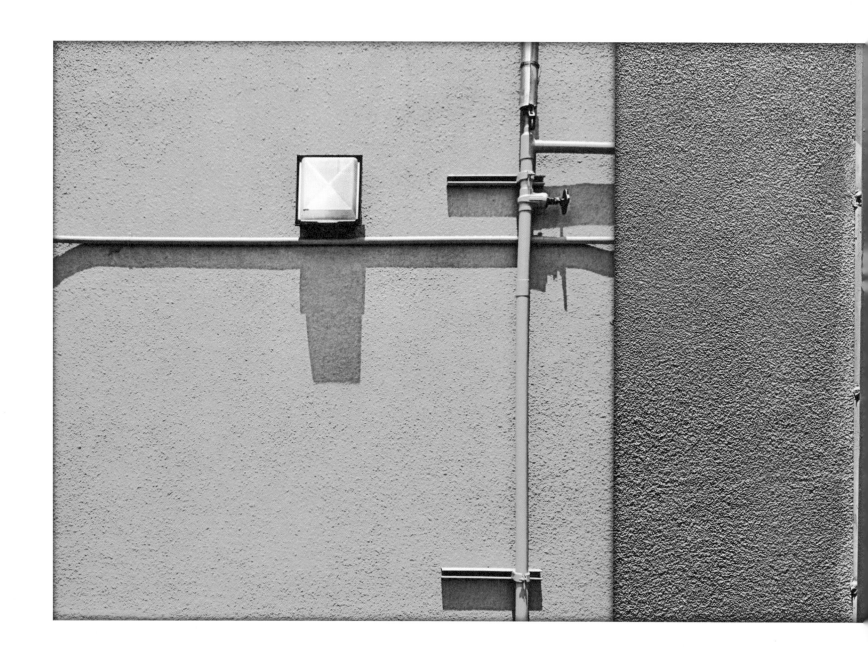

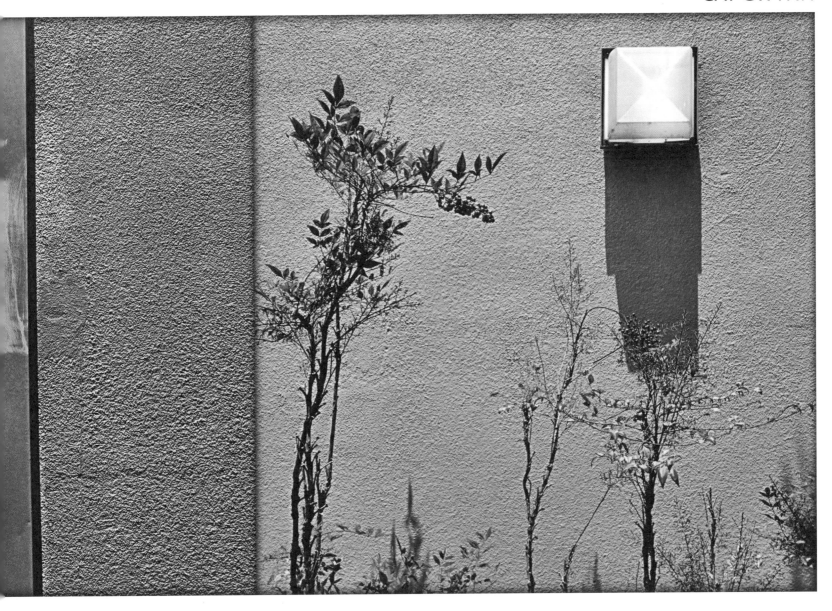

THIS IS A GENUINE RARE BIRD BOOK

A Rare Bird Book | Rare Bird Books

453 South Spring Street, Suite 302

Los Angeles, CA 90013

rarebirdbooks.com

A Rare Bird Book
Rare Bird Books Subsidiary Rights Department
453 South Spring Street, Suite 302
Los Angeles, CA 90013.

Set in Source Sans Pro and Raleway

All photographs by Cat Gwynn
www.catgwynn.com

Design by Kathy Martens
www.kathymartens.com

Printed in Canada
10 9 8 7 6 5 4 3 2 1

Publisher's Cataloging-in-Publication data
Names: Gwynn, Cat, creator.
Title: 10-Mile radius : reframing life on the path through cancer / Cat Gwynn.
Description: First Hardcover Edition | A Genuine Rare Bird Book | New York, NY; Los Angeles, CA: Rare Bird Books, 2017.
Identifiers: ISBN 9781945572043
Subjects: LCSH Gwynn, Cat--Health. | Breast cancer—Patients—Biography. | Street photography—California—Los Angeles County. | Los Angeles (Calif.)—In art. | Los Angeles County (Calif.)—Pictorial works. | Photography, Artistic. | Self-actualization (Psychology). | Buddhism. | Patients—Psychology—Personal Narratives. | BISAC HEALTH & FITNESS / Healing | HEALTH & FITNESS / Diseases / Cancer | PHOTOGRAPHY / Street Photography | PHOTOGRAPHY / Photoessays & Documentaries
Classification: LCC TR659.8 .G89 2017 | DDC 979.4/94—dc23

This book is for the seekers and the makers, for those who stand in their unmistakable radiance, and for those striving to rekindle their own spark. Remember, a brilliant light casts a long shadow. This is our full spectrum. Healing takes effort and courage. Trust your heart, it's a reliable compass.

When the waves close over me, I dive down to fish for pearls.

MASCHA KALÉKO

Fortitude

"I'm afraid!"

My mom grabbed me and held on tight. The choppy waves made the sea unpredictable—probably not the best day to plunge into learning how to bodysurf. But this was our day at the beach, and, fear or not, I was determined to catch a wave and ride it victoriously into shore.

I could feel my mom losing her grip on me, my suntan-oiled skin slipping from her fingers. The relentless undertow pulled at me. A huge wave bore down on us. Panicked, I started to swim for land as fast as I could, naively believing I could outpace velocity fueled by wind and gravity. The last thing I heard before being knocked over was my mother shouting, "Never turn your back on the ocean!"

Chaos. My body tumbling in a million directions. Sand, seaweed, rocks, choking down what seemed like gallons of saltwater. No matter how hard I tried to swim out of the vortex, I kept getting pulled under as the set of waves mercilessly pummeled overhead. Finally, I broke the surface gasping for air, wiped out and ready to call it a day. My mom yanked me out of the whitewater and asked if I was okay.

"No!" I cried. "The waves are too big and I'm too small. I can't handle it."

She wiped the sand off of my face. "Yes you can; you've just survived the washing machine. But before we try and catch another wave, I'm going to show you something even more important. How to save yourself."

"I don't want to get caught in the washing machine again. It's too scary," I said, shivering. I was ready to bolt back to the safety of my beach towel, but my mom wouldn't have it.

She took my shoulders and said, "Look, you're a good swimmer, but you've got to respect that the ocean is immense and uncontrollable. On the best day you'll mostly be maneuvering through waves, taking a few hits, and lucky if you catch a handful of good rides. You've got to watch how the waves are rolling, and if one is breaking too fast, don't try and swim away. Instead, dive into it and go under. You'll feel the tide churning over you; it's powerful, but hold your breath and go with the flow. When it starts to ebb, swim up to the top. I know this'll sound unbelievable, but it actually feels incredible to be underneath it all and trust you have the fortitude to meet the energy of the sea. You can do it, Cat."

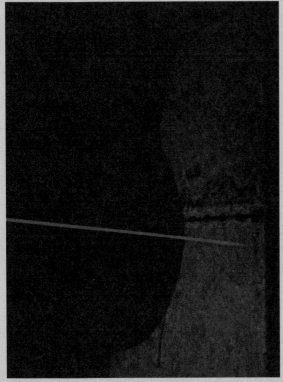

Radiation Beam Through Breast (treatment #12)

C ANCER HAS NOT BEEN GOOD TO YOU.

B UT YOU WILL CHANGE THE STORY.

W hat the hell is that? My heart stops, I quit breathing and break into a cold sweat. My mind starts to race. "Is it …? Oh god, please don't be that." I slowly bring my hand back, tentatively touching the upper part of my breast. It feels like a lump. But maybe it's not a lump? Could it be a swollen insect bite? I rip open my blouse and look at my chest but there's nothing there. Every synapse is a blaring multiple-fire alarm. I rush into the bedroom, throw myself down on the bed, fling my right arm over my head, and examine the area more deeply with my left fingers. The dense mass is undeniable. I've been trying to outrun this liability for over a decade, assuming my positive lifestyle will safeguard me. Dread seeps into my whole being. All I can think is: *this won't end well.*

I am surrounded by many degrees of cancer. All kinds of cancer, but particularly breast cancer. First-degree breast cancer. My mother died from it. Second-degree breast cancer. My maternal aunt had it, beat it, and is now battling ovarian cancer. We all had different subtypes of this disease, and none of us carries the BRCA1 or BRCA2 gene. This confounds my doctors. We likely have another gene mutation that hasn't yet been discovered. But no matter how or where cancer comes from in families, it's a legacy that is passed on generationally. Not always the disease itself, but the many degrees of its fallout.

A few years after my mom passed on, my brother-in-law Joe died of kidney cancer. Then, shortly before I was diagnosed with Triple Negative breast cancer, my friend Catherine perished from the same ruthless disease. And in the few years since my diagnosis, nine of my friends have been treated for or have died from cancer. Brain, breast, liver, myxofibrosarcoma, intestinal, ovarian, and pancreatic cancers. Varying grades. Varying stages. Varying degrees between life and death. It is seriously unsettling.

At the initial consultation with my oncologist, we review my family history and discuss the grueling treatment protocol particular to Triple Negative. Dr. Mita takes my hand and says, "Cancer has not been good to you. But you will change the story. I know you can do it." Her words sear into my heart: a clarion call to reframe my personal narrative.

My mom taped a handwritten note to her vanity mirror: "What legacy do I leave my three daughters?" She left me her demon ghosts. Humor, smarts, and innate curiosity too. I miss her terribly, and yet feel deeply betrayed by her.

My mother avoided conflict at the expense of our family. She sought validation and a sense of worth from men, contorting herself to accommodate their narcissistic demands. Acquiescing to my absentee father's volatile temper and self-involvement, and her second husband's self-righteous, alcoholic bullying, she was neglectful in standing up for herself or protecting her children. Her unwillingness to face things fractured everything.

Our family legacy? The freeloading second husband made sure she left that to him. She left me with deep-rooted insecurities I struggle to combat daily. She numbed them with alcohol. I took them on and they damned near killed me. Her unattended wounds became my battle scars. That note on her vanity still haunts me. Demon ghosts and her best intentions.

What happened to the loving mom who encouraged me to pursue my passion to be an artist, have adventures, and make a genuine difference in the world? What undid the self-proclaimed feminist who taught me how to save myself, and insisted I assume personal sovereignty? She left many unanswered questions in the wake of her death. The well-intentioned woman who wanted all these things for herself made choices that contradicted her life's wishes. She was a mother whose polarizing nature modeled for her girls that in order to hold onto love you have to let go of yourself. Her role as dutiful placater superseded the province of mothering. I carry this dichotomy, which makes grieving her so complex.

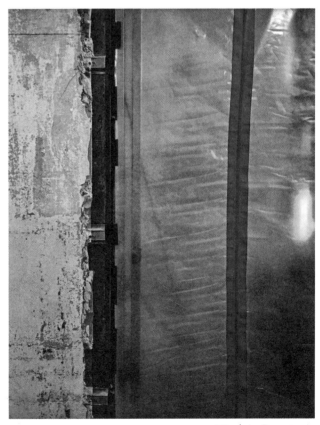

Nothing can prepare you for a cancer diagnosis. It's shocking and surreal. The myriad of emotions it stirs up are overwhelming. Regret. Is this my fault? Weren't all my precautionary measures enough? Could I have done something more to prevent it? Anger. It comes in waves. This is so goddamn unfair. I can't handle one more loss, fight one more thing. But this is immense; if I try to fight it, it'll pull me under.

Breathe. I've made it through so many other obstacles and overcome incredible challenges throughout my life. I will survive this too. Fuck. I am done just surviving.

Work In Progress

Portal. An entry. It opens. A vein. The rabbit hole my heart is tumbling down…

My left arm is throbbing; the tight bandage almost prevents me from bending it. My friend Terri has gone downstairs to pick up my antibiotics. I wait for her outside the procedure center, standing next to a large door opening onto the skywalk that extends from the South Tower at Cedars-Sinai over to the Advanced Health Science Pavilion. The door swings back and forth as people cross between buildings. My arm pounds in unison with the beat of my racing pulse. The surgeon who implanted the Port-a-Cath said post-op shouldn't be too painful. After a while I won't even notice it's inside me. Won't notice it? It feels like he sank a scalding bolt into my arm. I want to wrench the alien invasion out of my body. Where is Terri? I just want to go home and crawl under the covers.

I inherited a small container of my mother's ashes. A whole life portioned off into a little ceramic vase. There was no funeral. The tenuous bond that connected and contained my family shattered the night she died. On her deathbed she asked to see the world through my eyes. Take in all the beauty, pathos, and wonder, and think of her. Let her spirit infuse my vision, melding our hearts eternally. When I travel I carry her ashes in a 35mm film canister. It feels fitting. I've taken her to many incredible destinations throughout the world, leaving behind a dusting of her essence to mark our path to someplace more expansive than death. One time, parceling out some of her ashes, a titanium screw plopped into the canister: a tangible remnant from a badly busted-up ankle. The restoration outlived her body.

Transfixed, I watch the flow of people traversing the skywalk. It glows with the promise of state-of-the-art medicine waiting on the other side. A shadow of fear falls across my destiny. Recollecting my mom's fate, I wonder if my newly inserted port might survive me. Future tripping constricts positive outcomes. For now, I let my eyes grow accustomed to the dark and trust my heart's illumination to lead the way through.

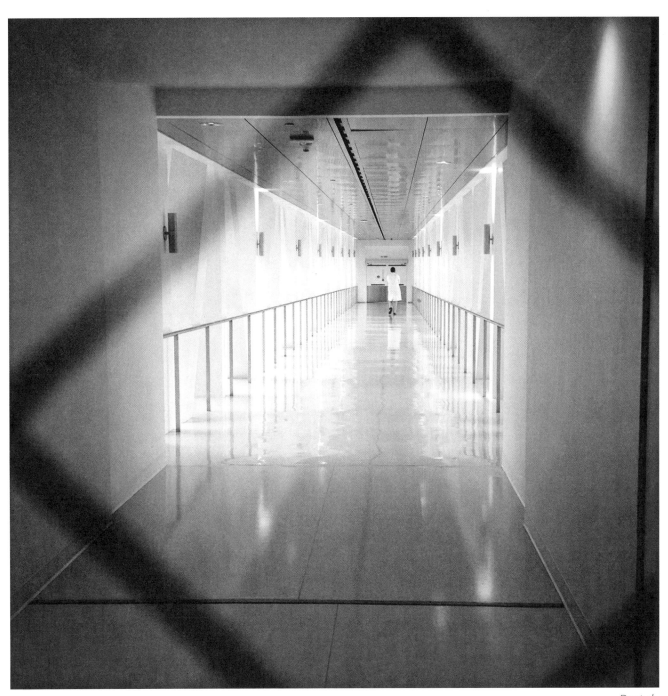

Portal

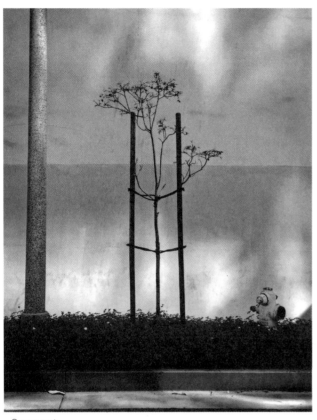

Support

Cancer swept over my life like a tidal wave. It washed away any sense of agency I thought I possessed. It left me uprooted and laid bare. With no family to turn to, I charted my own course, determined to navigate this predicament with as much grace and mettle as I could muster. Friends rallied with sincere support, insisting, "You're a fighter, Cat. You can beat this." I truly appreciated their encouragement but knew better. If I took on a battle with cancer it would kick my ass. I called a truce. The sizable mass in my right breast was a part of me: my cells, my being, my legacy. Trying to hate it away wouldn't eradicate it. Loathing aspects of myself would only erode my capacity to recover. My doctors and the targeted therapies could combat the cancer. I needed a wholehearted strategy to overcome fear and despair. The more crucial fight for me would be with my mind.

Concerned I'd be caught inside the hardwired impulse of "no," I committed to having a relationship with my illness, willing to say yes to it all. Embrace my cancer, the treatments, having chemo brain, metal mouth, bone ache, frozen shoulder, radiated skin irritation, neuropathy, exhaustion, and baldness. Bring on the blood draws, heparin flushes, MRI, CT and PET scans, ultrasounds, mammograms, surgeries, biopsies, and pathology. Be with the not-knowing and endeavor to know a deeper side of myself. My longtime meditation practice could help me sit with reality, but I needed to balance it with another engaged way of being. I'm a photographer and love what I do for a living, so I decided to seek out and capture images every day that would connect me to life—a gratitude practice in motion.

I dove into the flow of my daily art-making exercise. To keep things manageable, I chose the simplest camera I own: my iPhone. Color, form, reflections, ironies, and insights appeared everywhere, prompting my impressionistic response. Moments normally overlooked now felt precious. It all called out for my attention.

My mortality stripped away supposition and broadened my sense of connection. I attuned to the immediacy of each day and found my purpose. This unique form of journaling transformed my vulnerability into substance and conception into stories. Cultivating a playful imagination paved a joyful path forward into the unknown. The stronger my creative muscle became the more my heart and eyes opened. Everything felt possible.

Cancer reduced my life to a ten-mile radius. I traveled to and from treatments. I saw doctors, went to physical therapy, psychotherapy, and acupuncture; I took vitamins and herbs, juiced, did Reiki and yoga, and meditated. I socialized on occasion, but even with my holistic regimens, I had to be careful of large crowds to protect my compromised immune system. I shot photo assignments on a limited basis, but all the therapies and side effects left me too exhausted to work full time. Through it all, I documented elements of humanity I discovered each day.

Steroids diminish the side effects of chemo, and one of the byproducts of steroids is insomnia. Imagine being sapped and amped at the same time. It's intense. I slept for hours then found myself awake in the middle of the night. To counter the frustration of my off-kilter schedule, I taught myself how to use a variety of photo apps to edit my growing collection of pictures. As my neighborhood slumbered, I sat propped up in bed with my phone processing photographs…processing my feelings, working them through filters, finessing tone, building depth, and further delving into my experience. Every detail and each layer was fully contemplated. It was cathartic and invigorating. I crafted my photographic pilgrimage and sent it out into the world, all from the palm of my hand.

I posted images regularly to social media without revealing my illness. I chose to keep it personal and let my photos chronicle my odyssey, rather than let my precarious health status define me. I wanted my vision to spark vitality and have it mirrored back. My network responded by uniting their inspired outlook to my concentrated point of view. Their enthusiasm provided an unwitting support system, an affirming reinforcement more restorative to me than well-wishes ever could have been. The lively interaction between my intimate observations and the great anonymous cyberspace expanded my existence well beyond ten miles.

A closed circle contains the whole universe. Isolation and loneliness become a catalyst for connection. Having an honest interchange with the very thing that threatened me, saved me. It empowered me to rise up and meet myself in ways I never could have imagined.

CANCER REDUCED MY LIFE

TO A TEN-MILE RADIUS.

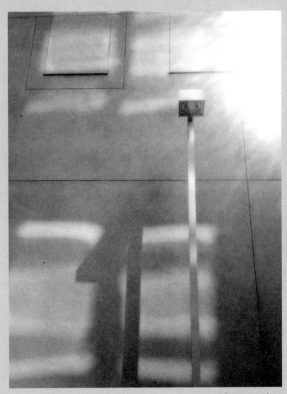

White Light

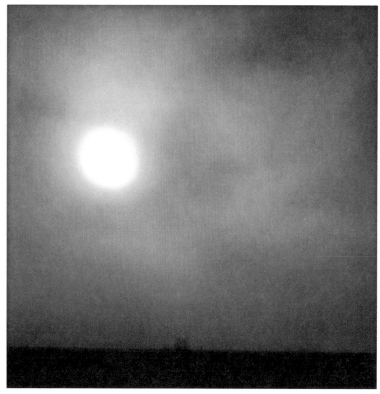

Guardian

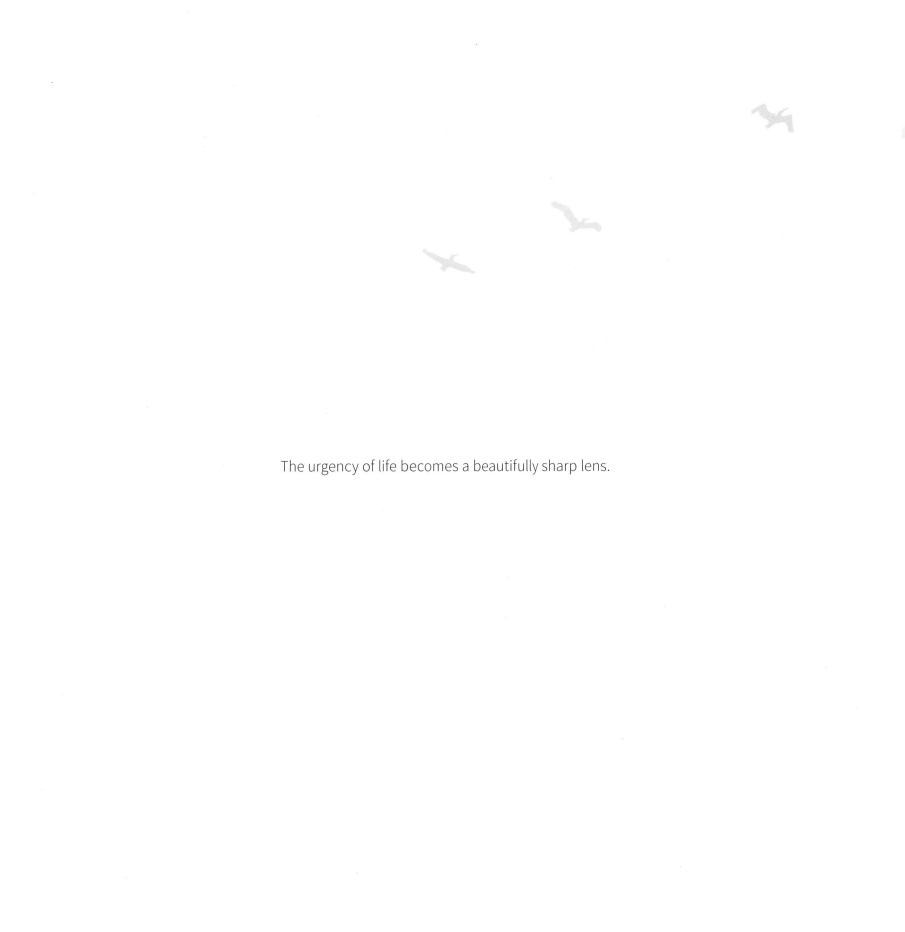

The urgency of life becomes a beautifully sharp lens.

There is no controlling life.
Try corralling a lightning bolt, containing a tornado.
Dam a stream and it will create a new channel.
Resist, and the tide will sweep you off your feet.
Allow, and grace will carry you to higher ground.
The only safety lies in letting it all in—
the wild and the weak—
fear, fantasies, failures, and success.
When loss rips off the doors of the heart
or sadness veils your vision with despair,
practice becomes simply bearing the truth.
In the choice to let go of your known way of being,
the whole world is revealed to your new eyes.

—Danna Faulds

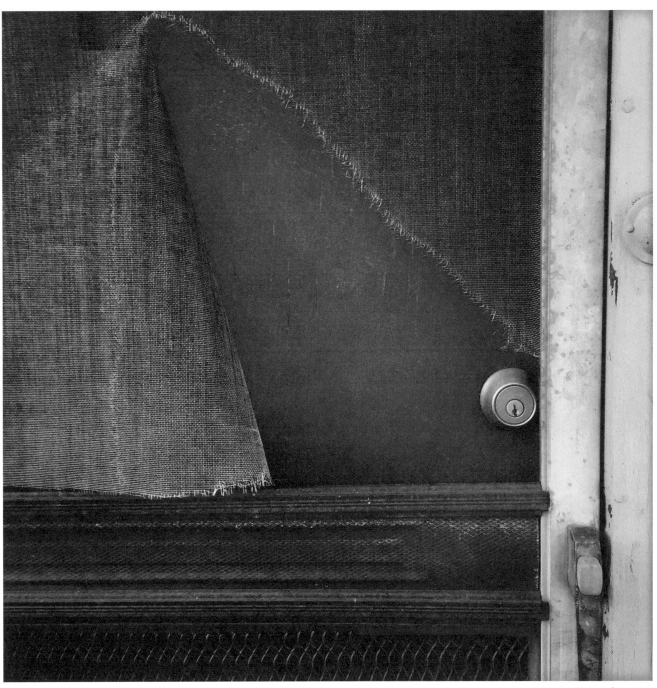

Ripped Open

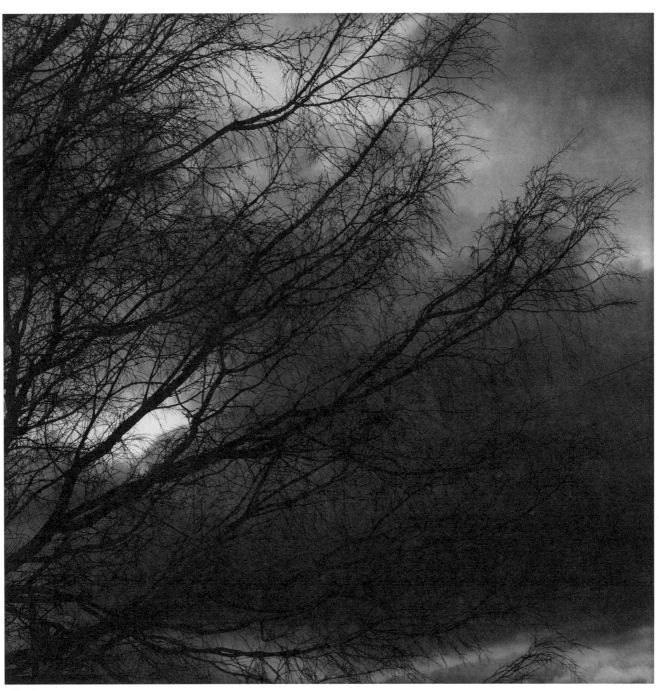

Ominous

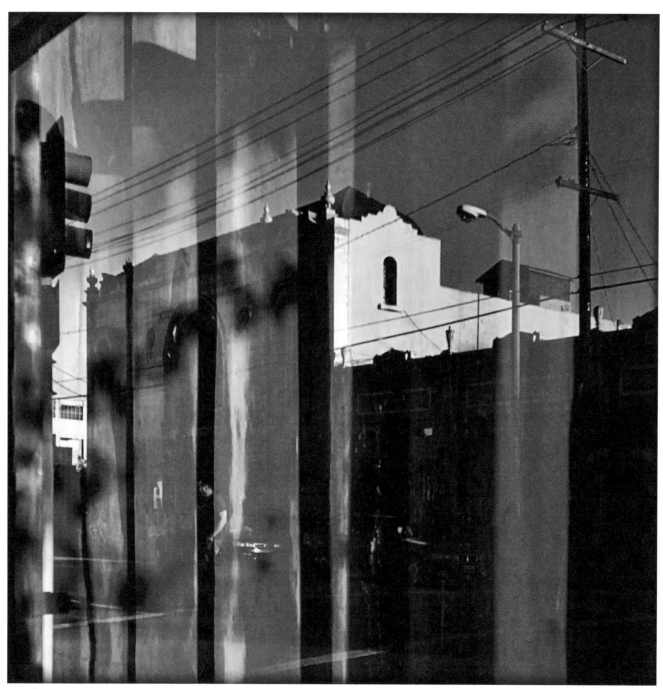

Red City

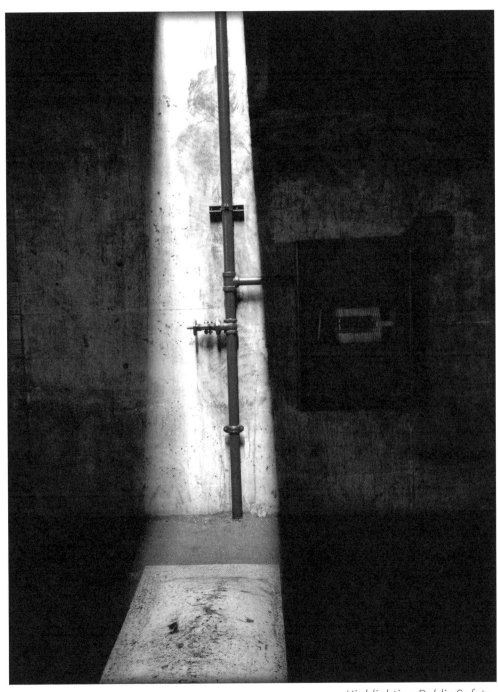

Highlighting Public Safety

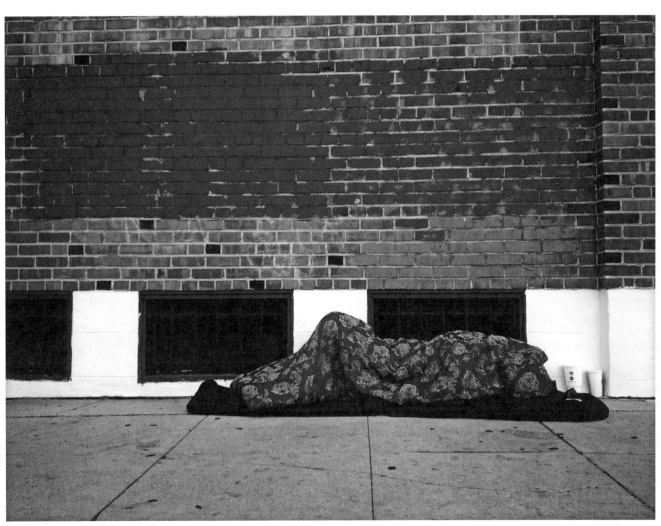

Light Sleeper

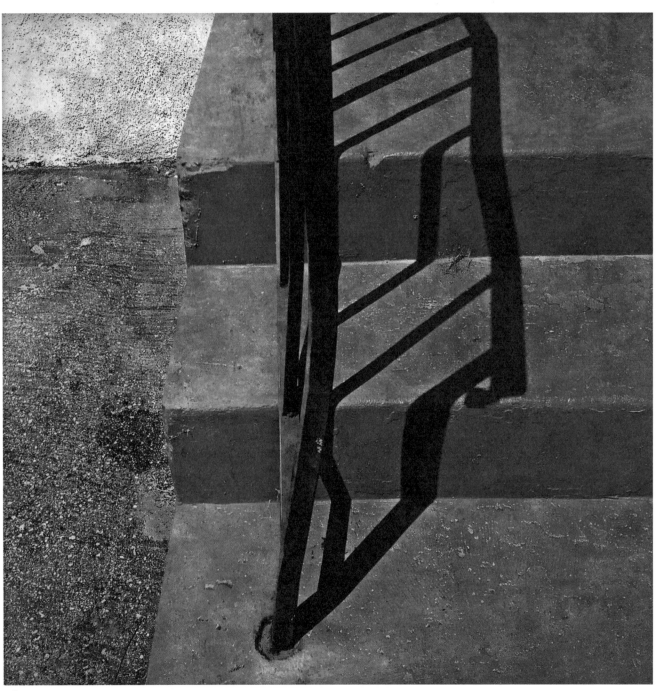

Gateway

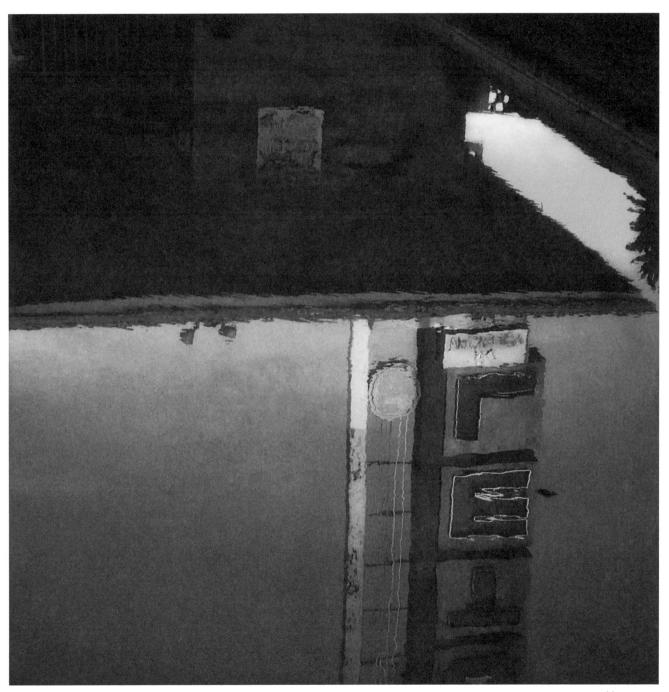

Vacancy

Let this darkness be a bell tower
and you the bell. As you ring,

what batters you becomes your strength.
Move back and forth into the change.

RAINER MARIA RILKE

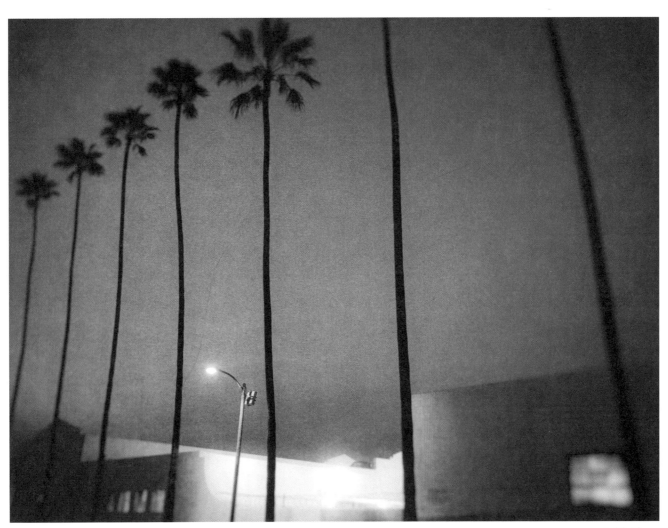

Initiation

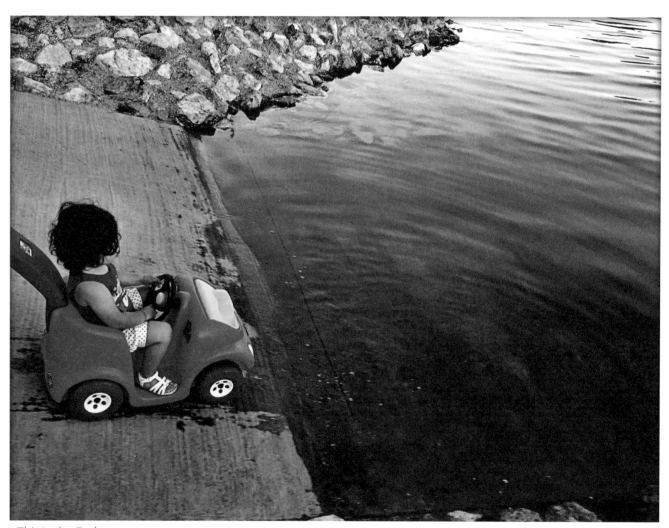

This Is the End

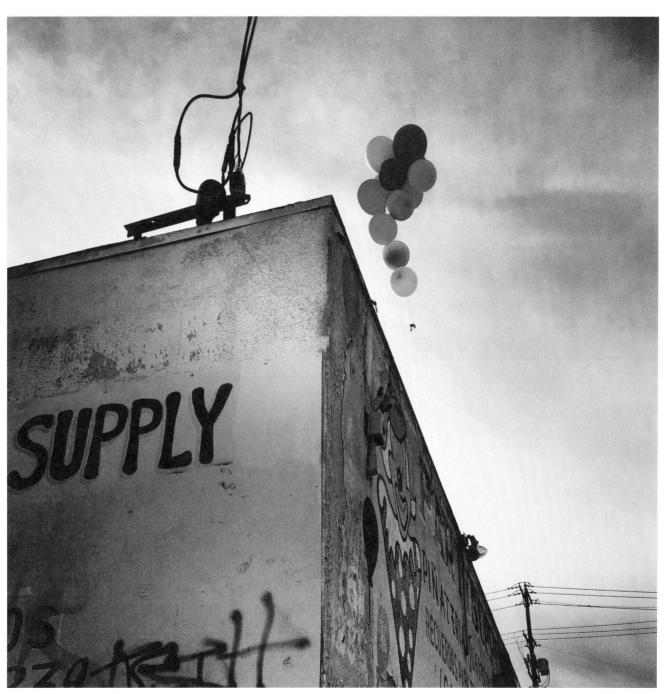

Breathe

Your life feels different on you,
once you greet death and understand your heart's position.

LOUISE ERDRICH

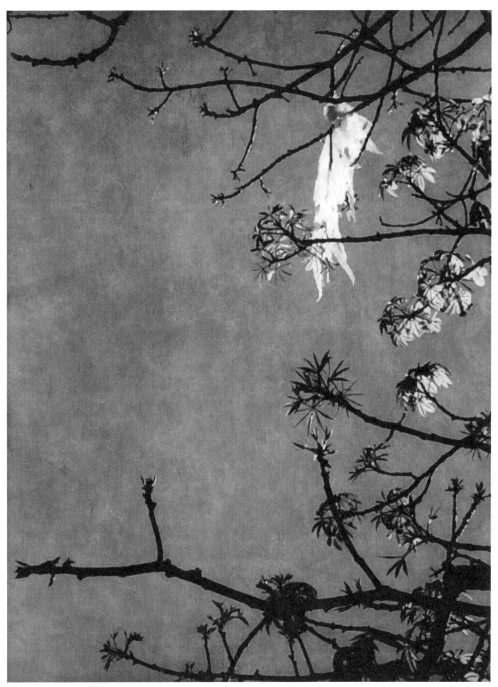

Ghost of Kitty's Past

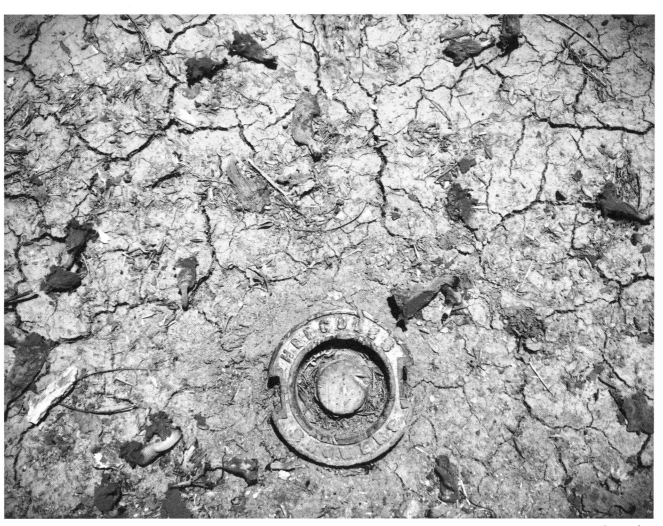

Drought

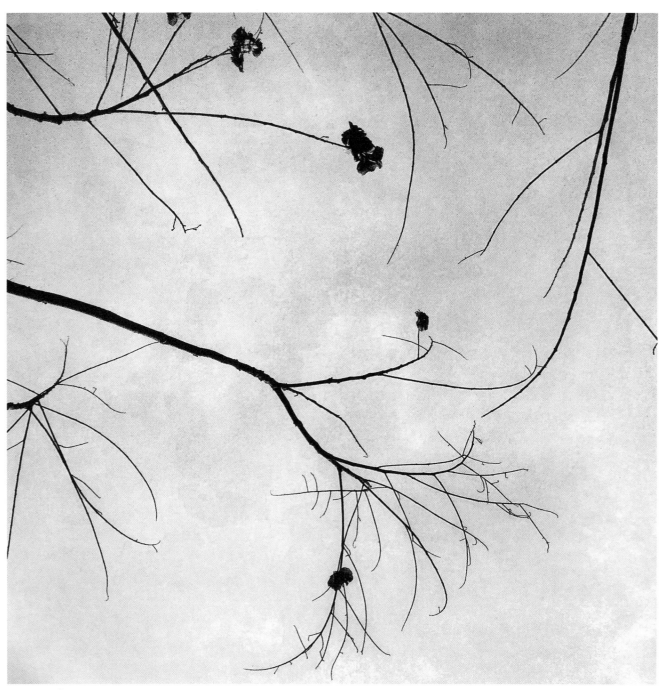

Exposed

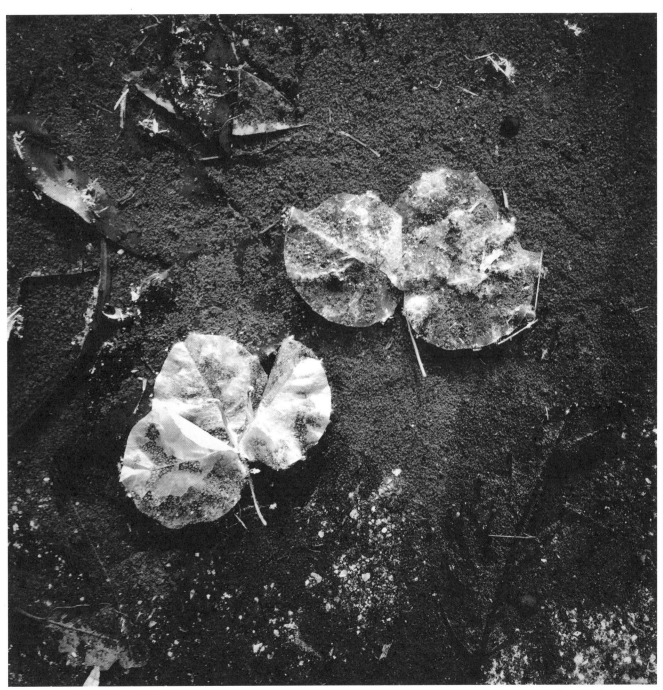

Glory in the Gutter

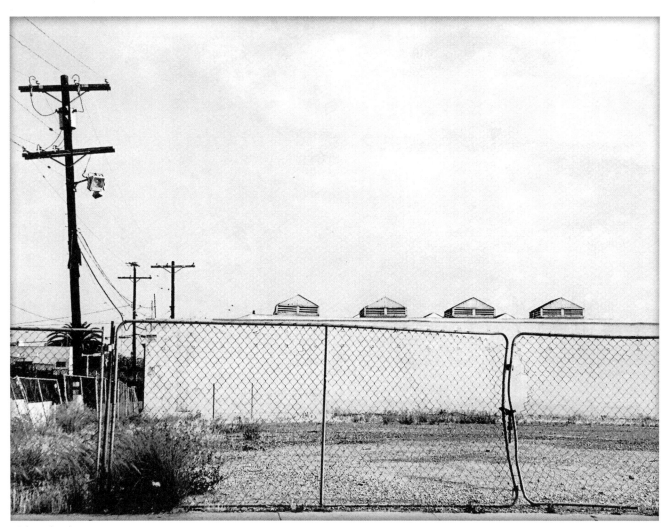

Blanched

One must say yes to life, and embrace it wherever it is found—and it is found in terrible places...
For nothing is fixed, forever and forever, it is not fixed; the earth is always shifting, the light is
always changing, the sea does not cease to grind down rock. Generations do not cease to be
born, and we are responsible to them because we are the only witnesses they have.

JAMES BALDWIN

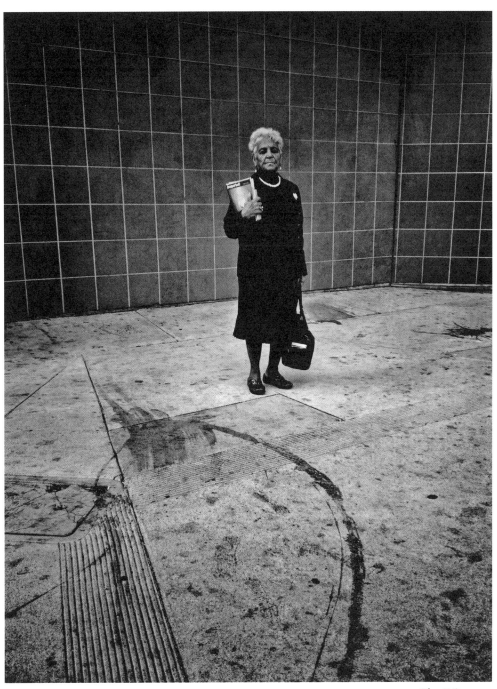

The Witness

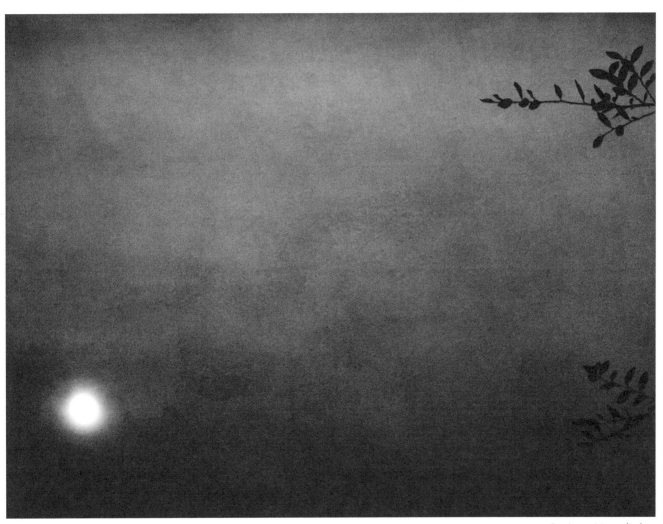

Serious Moonlight

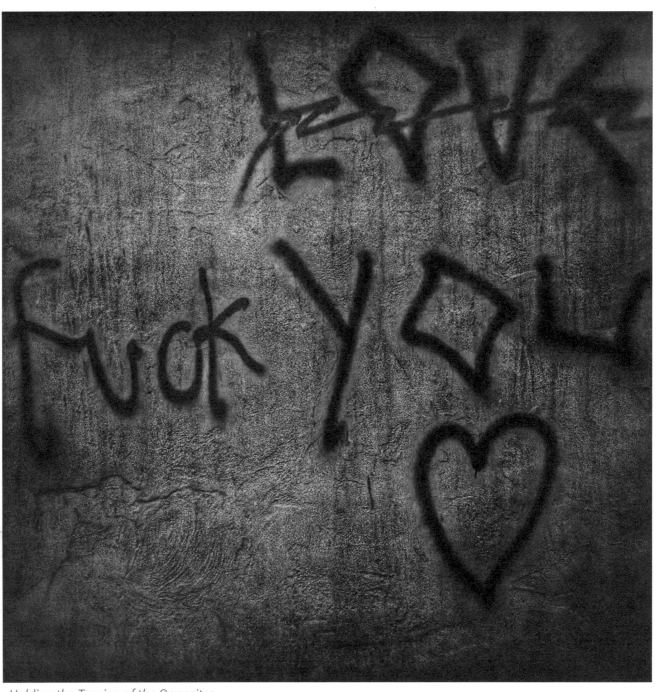

Holding the Tension of the Opposites

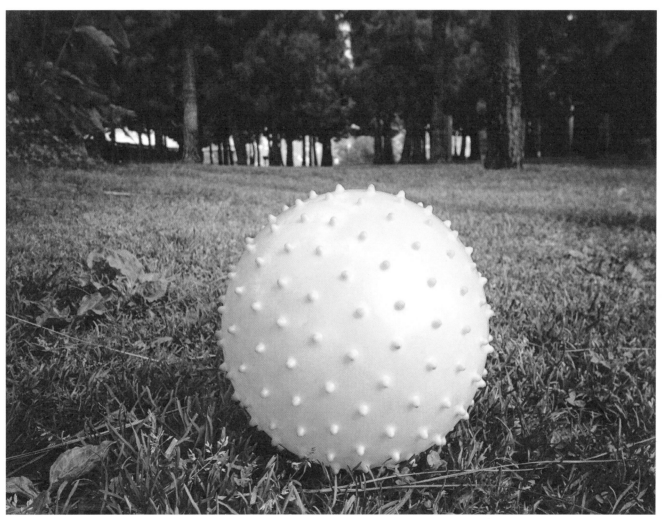

Sometimes the Sun Pretends to Be a Ball Resting in the Grass

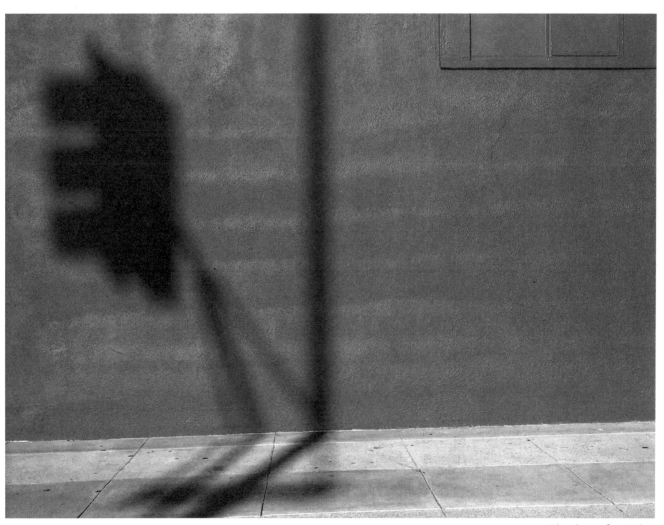

Shadow of a Light

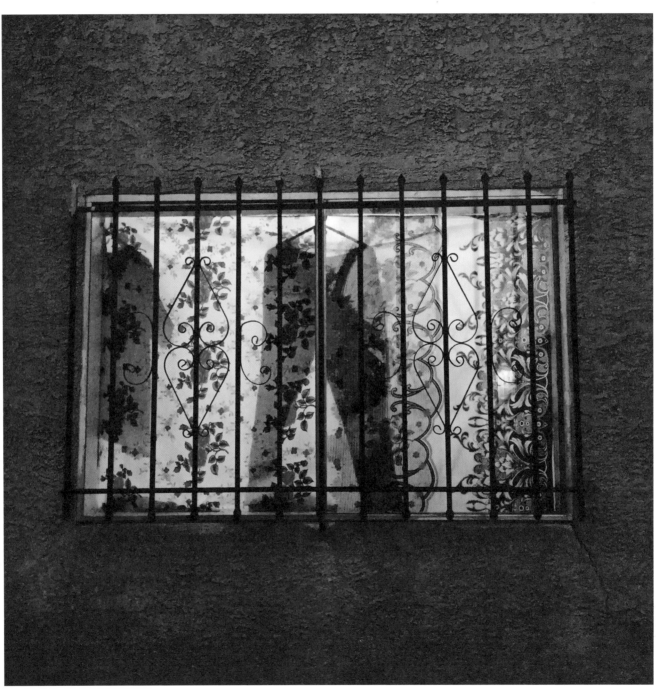

Hung Out to Dry

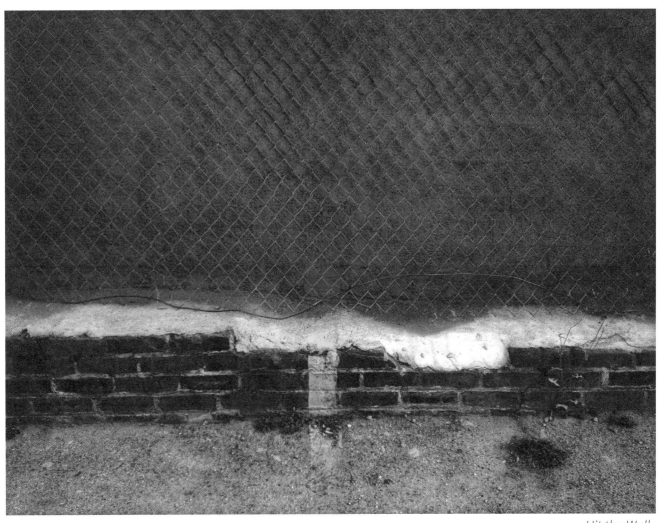

Hit the Wall

Jay Goldberg is nineteen, wildly intelligent, seriously motivated, outwardly awkward, and loves his covert job. He makes up seductive profiles for a shady dating site. A few times a week he heads over to the local Starbucks and fuels up on iced passion green tea and bangs out twenty or so false identities at twelve bucks a pop.

Sunny Ray Jenkins: 41, a busty, longhaired ginger babe who makes a mean peach cobbler, loves NASCAR, the Home Shopping Network, and Ronald Reagan.

Patrick Clooney: 50-ish, salt-and-peppered, with the general consensus being his cousin George is the poor man's Patrick Clooney.

Hester Wong: 24, diminutive with delectable double D's and an alluring Malaysian lisp, specializing in tantric-organic-colonic massage therapy.

He's on an entrepreneurial mission: Jay's goal is to own and operate *Liger Replica*, a celebrity look-alike agency that specializes in models who are a hybrid of popular personalities. With six more profiles to go, Jay slurps down his second passion green tea and envisions presiding over his domain as Napoleon Timberlake.

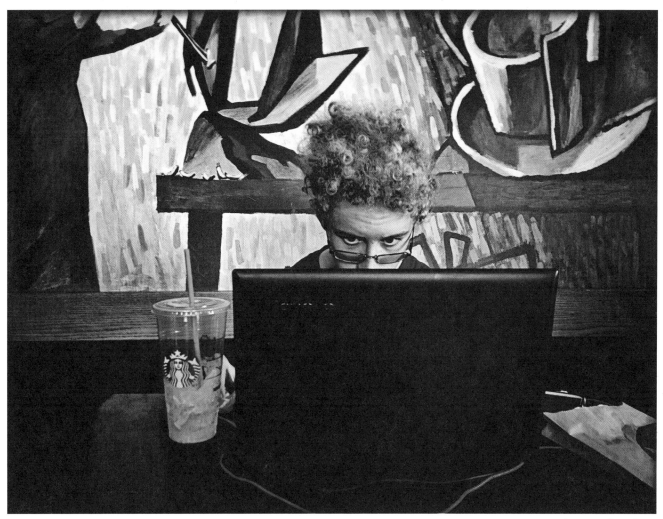

The Matchmaker

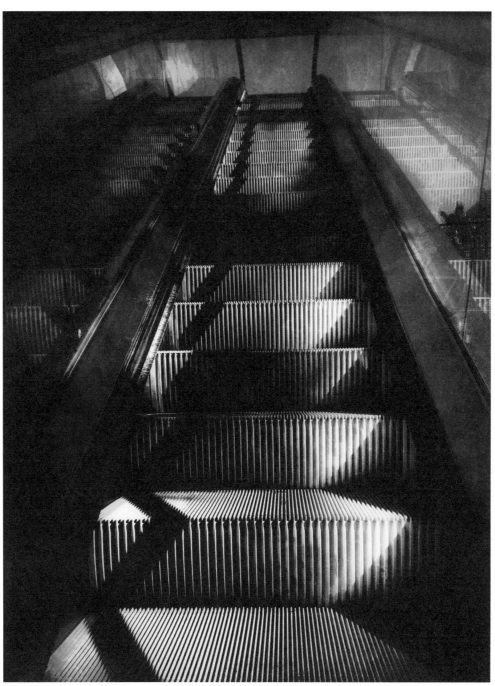

Dreams of Being Upwardly Mobile

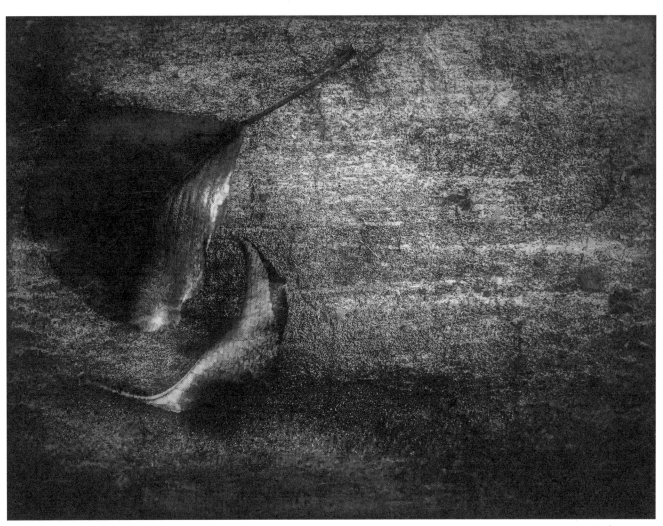

Belonging

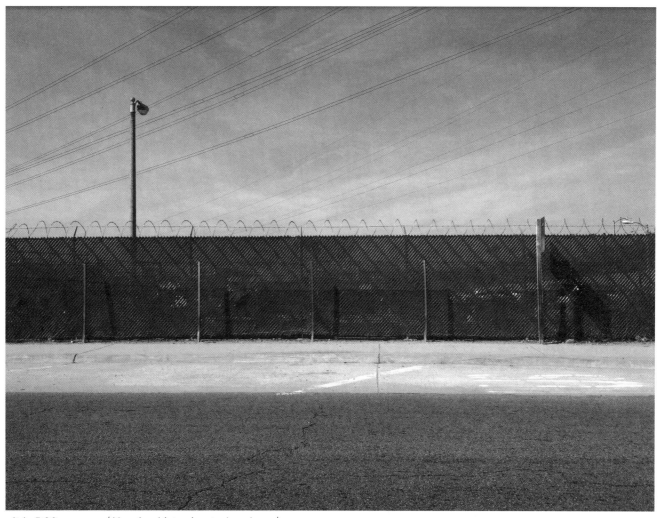

It Is 5:00 p.m. and You Are Listening to Los Angeles

Rush hour: exiting freeway, waiting for green light, a break in opposing traffic. Breathing in: I am here.

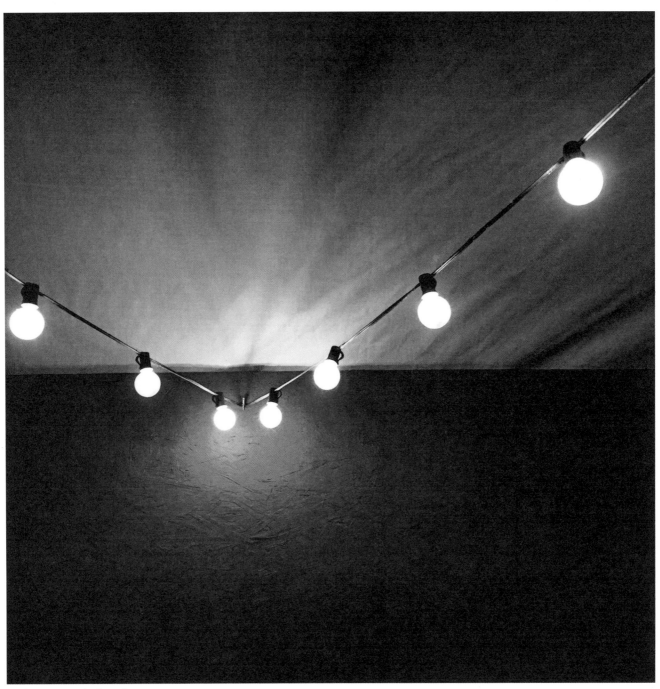

At Peace with the Obvious

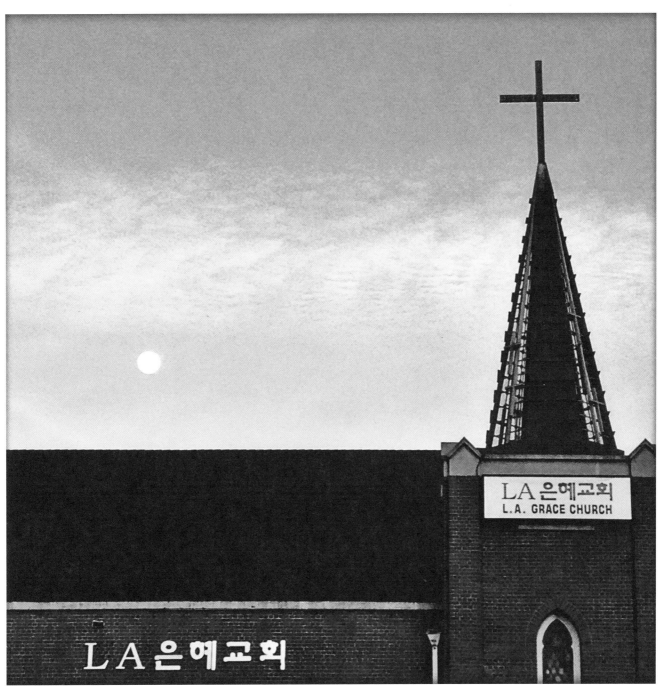

The Moon Is My Religion

Click-clack, click-clack, clickity-clack. Click-clack, click-clack, clickity-clack-clack...

Constanza walks with a swing in her step. Doesn't matter if she is walking to work, walking to go watch her grandbabies, or walking to pick up groceries, she always finds the rhythm of the street. Her hips gyrate spice.

She grew up on Bachata and Merengue, never missing a chance to go to the clubs and dance her life away. She still goes clubbing on the weekends with her boyfriend, Narcisco. Her kids laugh and call her *abuela loca*, but she doesn't care. Life is a fiesta and should be played like you're backed by a red-hot horn section. *Cha! Cha! Cha!*

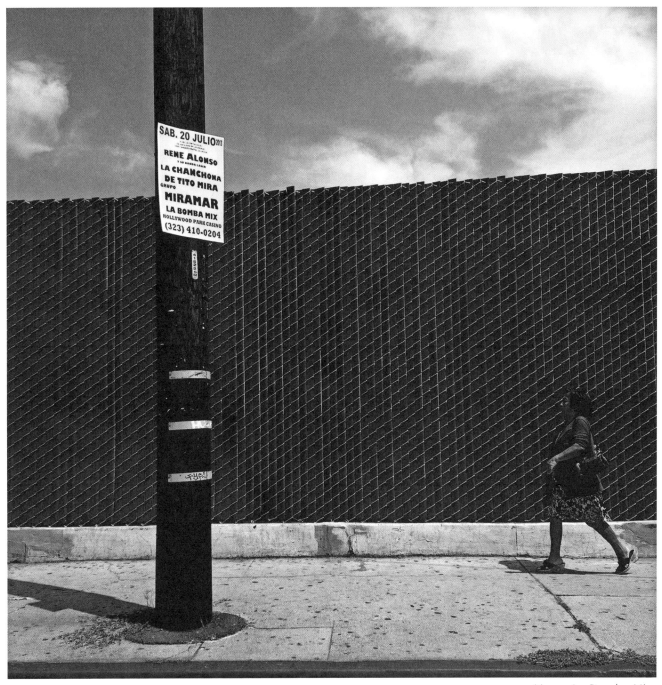

Mama La Bomba Mix

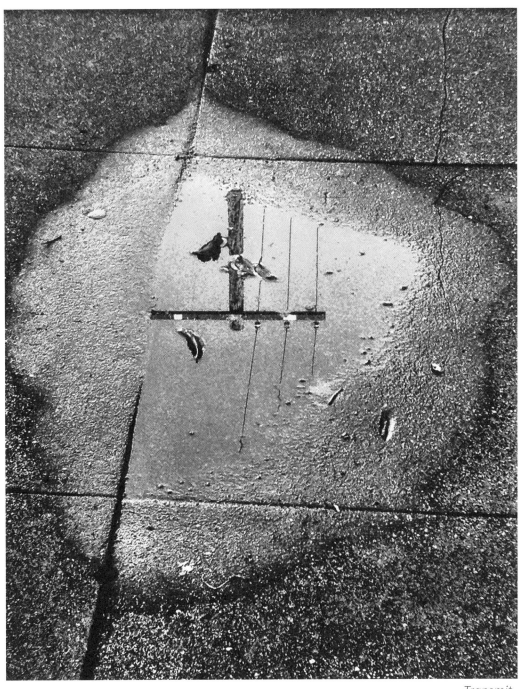

Transmit

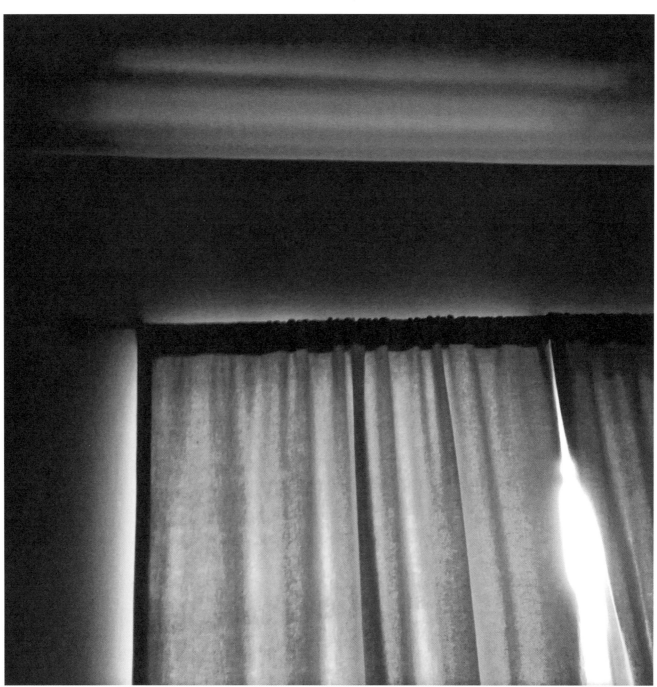

Barely Contained

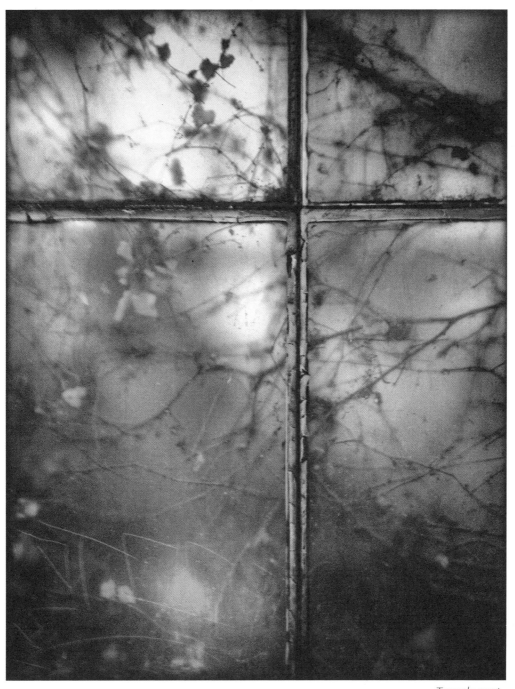

Translucent

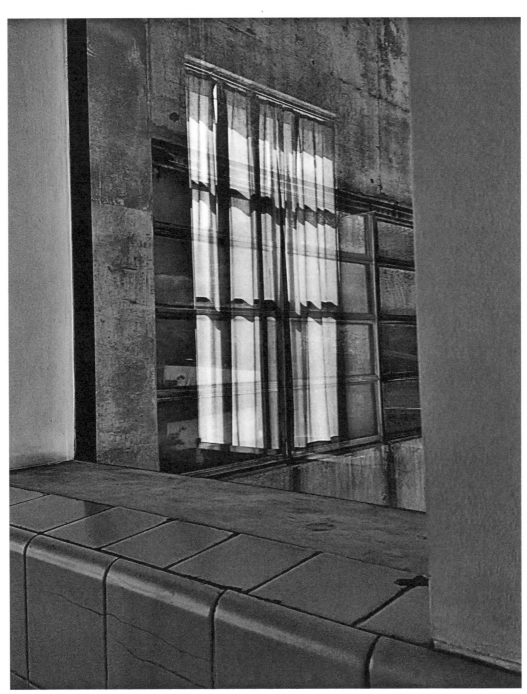

Turn and Face the Strange

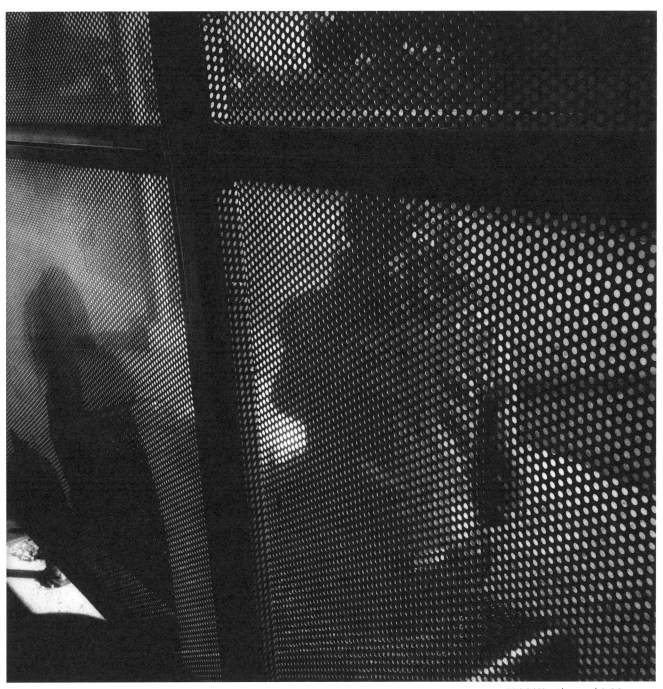

#206 Westbound 3:33 p.m.

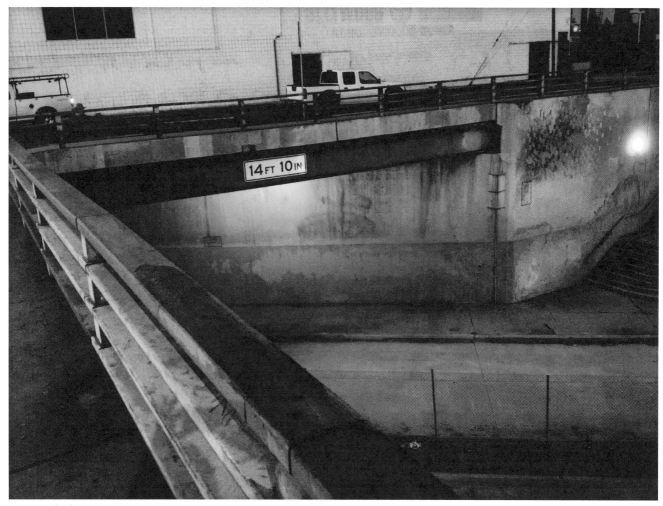

14 FT 10 IN

Vertical Clearance

The size of the place that one becomes a member of is limited only by the size of one's heart.

GARY SNYDER

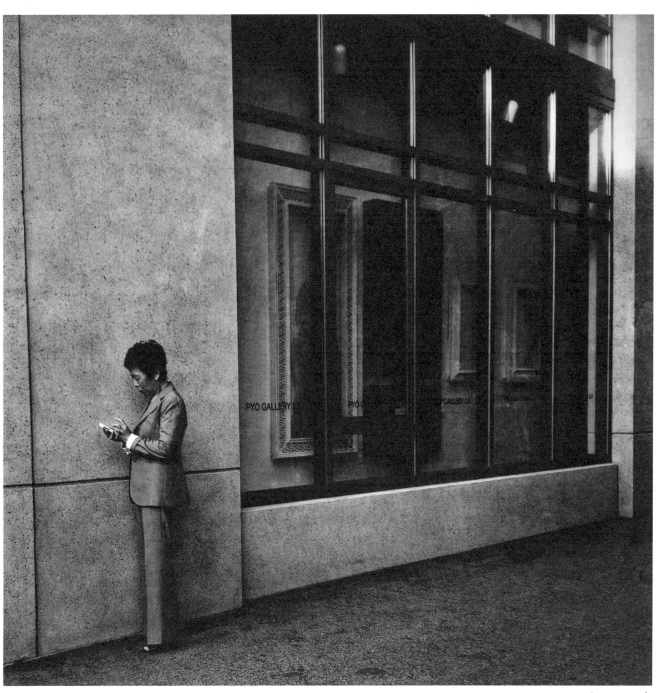

Immersed

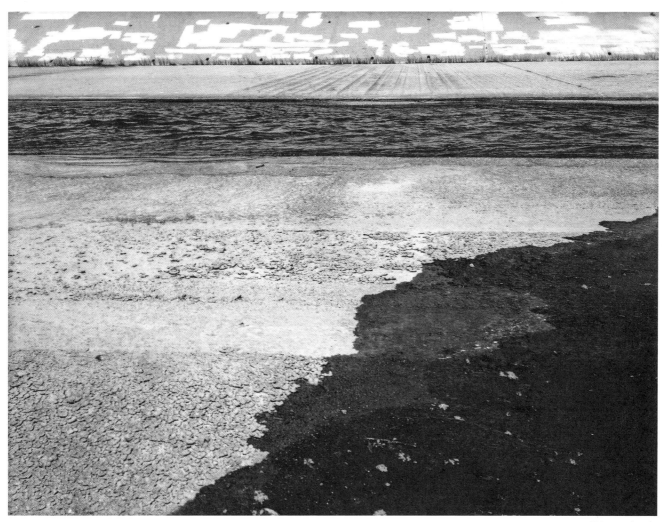

Watershed

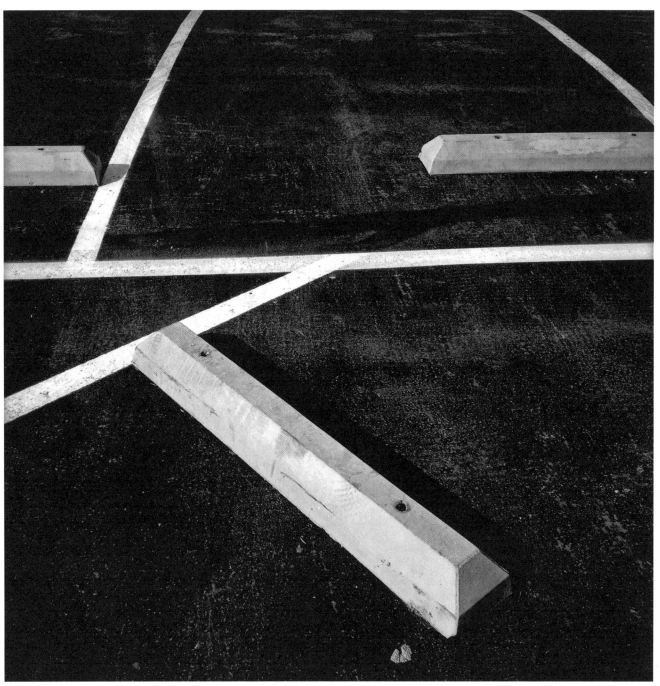

They Paved Paradise

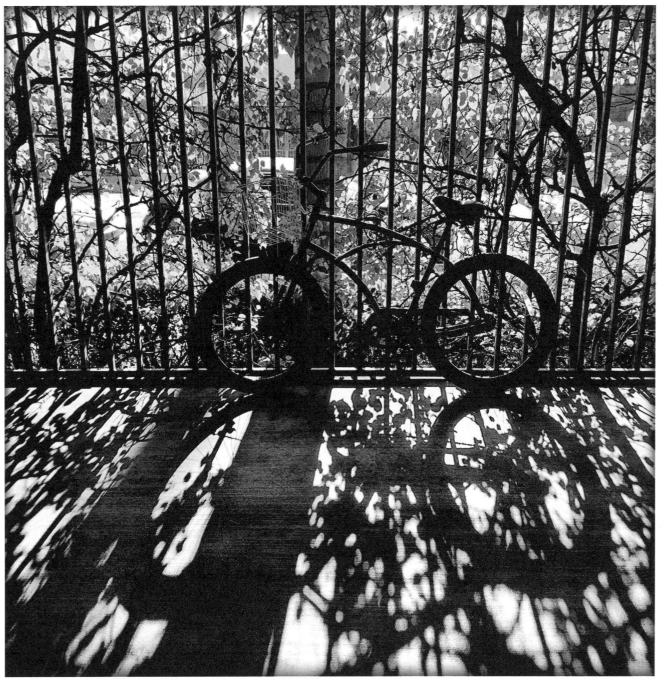

Shadow Cycle

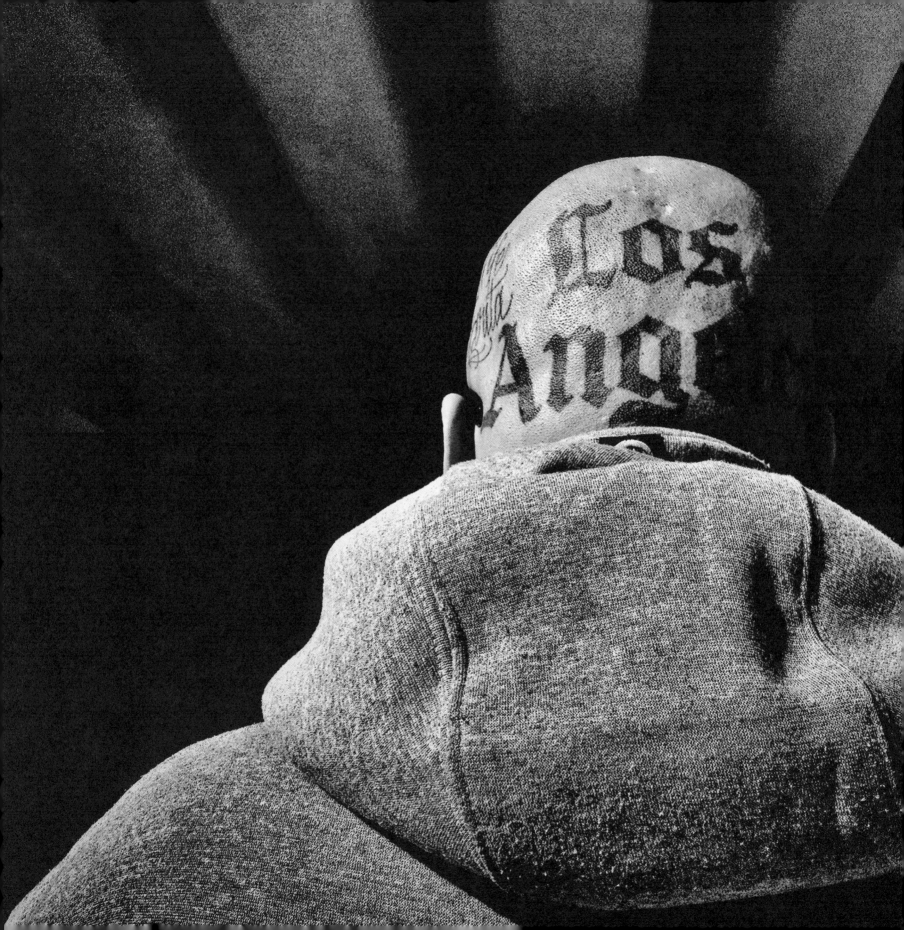

RADIANT PEOPLE

Finally, radiation. I'd had my lumpectomy, done tons of chemo, and was now looking at thirty-three rounds of radiation—five days a week for the next few months—the last part of my treatment protocol. I chose a facility close to my home. It was a mile each way, so I figured I'd get some exercise and could make photos along the way.

I start observing all of the people I passed on my daily walk to treatment. We all seem so different when really, at our core, we're the same. I think about how we often go through life making snap judgments and assumptions. Perhaps it's a way we distance ourselves from taking in the deeper truth of what another person's life might hold…what our own life might hold. These folks don't necessarily know I'm going through cancer. I certainly don't know what they're going through.

But we all have a story.

One day on my walk, I cross paths with a hard core gangbanger. He has this stunning tattoo on the back of his bald head. I want to photograph him so bad. But you can't just ask a gangbanger if you can take his picture. Then I think, why not? You're overcoming cancer. Just ask.

I approach him. He's a bit guarded; shoots me a daring look, like, "You wanna take my picture?" I take off my hat. His eyes widen when he sees my bald head and he says, "Oh," then gently nods yes.

He walks a little further up the street and stops at an entrance to a building. I look up and see these ceiling beams above him. They seem to be spreading out from his head…like this radiance of spirit. The photo gods are with me.

Asking to be seen and subsequently someone giving you permission to see them can be an uncomfortable proposition. But setting mistrust aside clears fertile ground for breaking through stereotypes. It allows us to see one another honestly. In this moment we are here, our hearts are connecting, and there is an energy that flows between us…life force.

Twenty-two more rounds of radiation to go. I decide that every day I will stop at this building and make a portrait of whoever shows up. Some days the first person I ask says yes. Other days I approach a half-dozen people before anyone agrees. It's hard; I ache to be done and head home, but I reaffirm: *not until you've made someone's portrait.* For me, follow-through is vital.

I met many lovely people there, under the radiant beams. The angels. The empathy we reflected to one another bore witness to all the joys and sorrows of living.

ANGEL

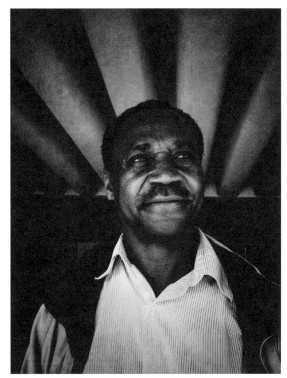

CHARLES

This place where you are right now
God circled on a map for you.

HAFIZ

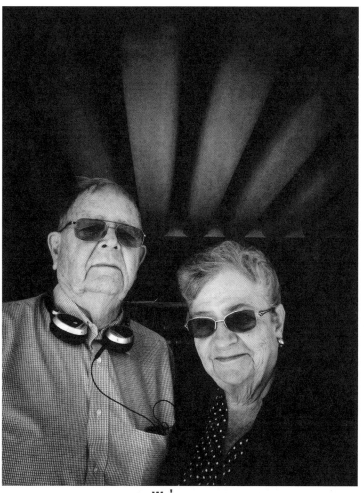

WE'VE BEEN MARRIED FIFTY-NINE YEARS.

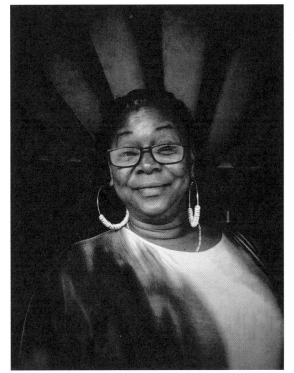

VERA

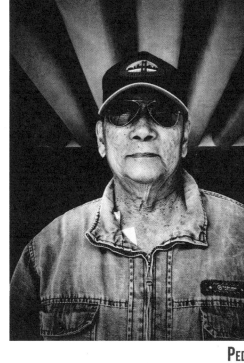

PEDRILLO

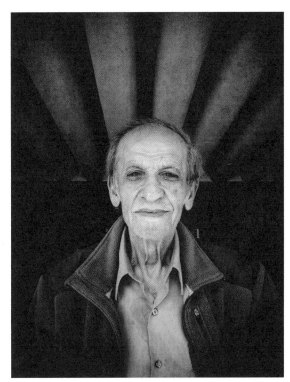

ZORBA

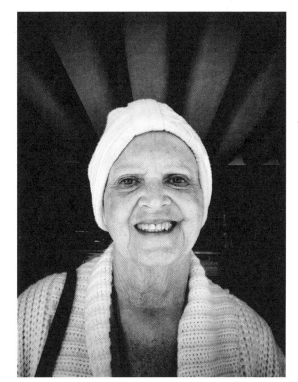

MICHELLE

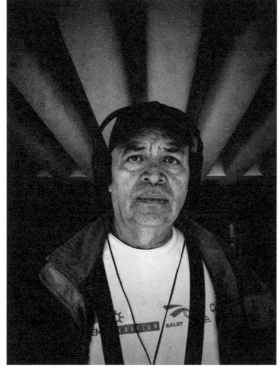

ROBERTO

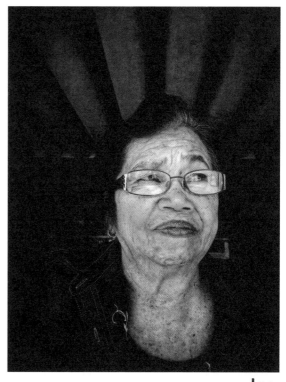

LILA

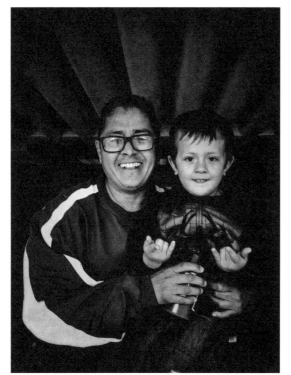

RALPH & JOSEPH

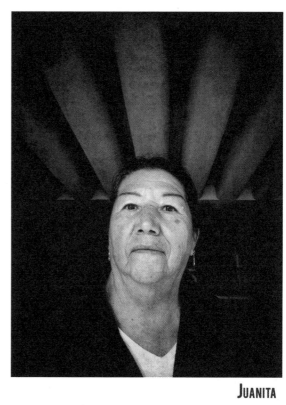

JUANITA

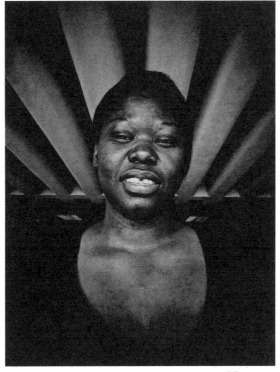

MARSHA

Every person can walk down the street, pick anybody out of the crowd, and they'll tell you a story that'll break your heart. Anybody. Every single person, somewhere in their life, is driven to a point of despair, where they just want to quit. And they don't quit. They don't quit because there is a capacity for, a desire for, reciprocated love that brings you back to life.

BARRY LOPEZ

You are an aperture through which the universe is looking at and exploring itself.

ALAN WATTS

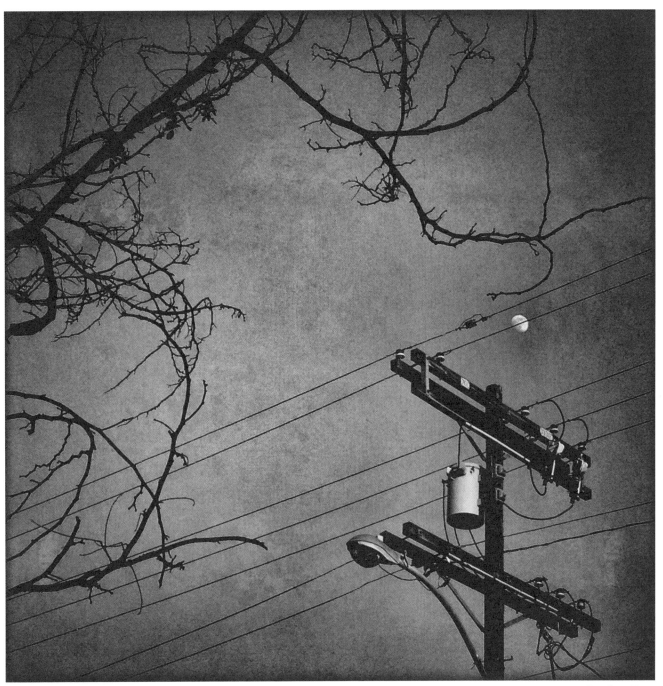

Moon On the Wire

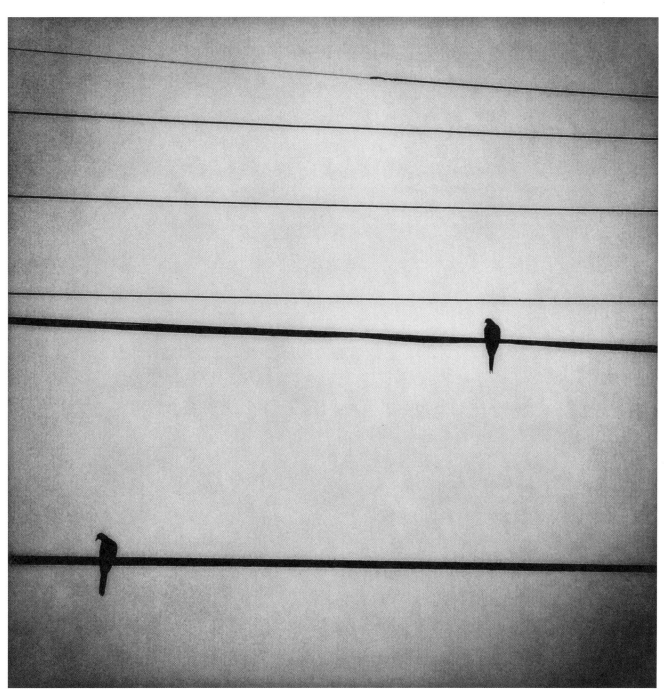

Connected

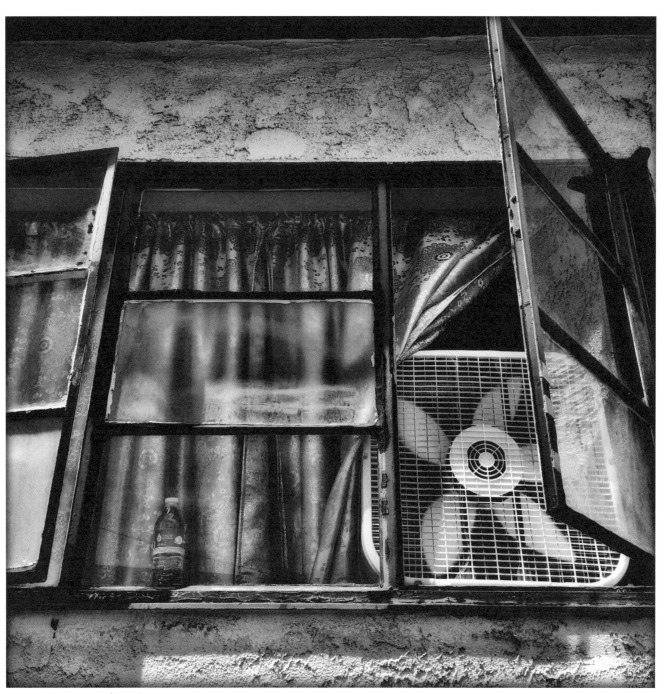

Basic Elements of Cool

Life is at the bottom of things and belief at the top,
while the creative impulse, dwelling in the center, informs all.

PATTI SMITH

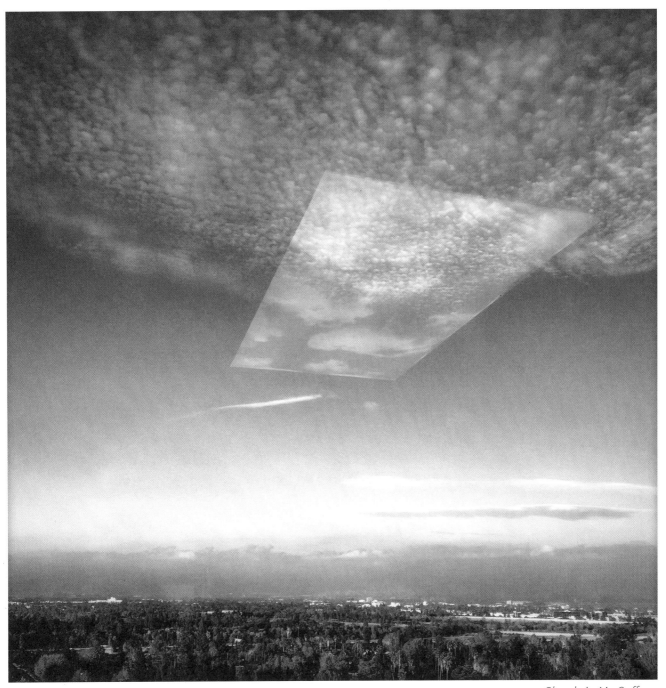

Clouds in My Coffee

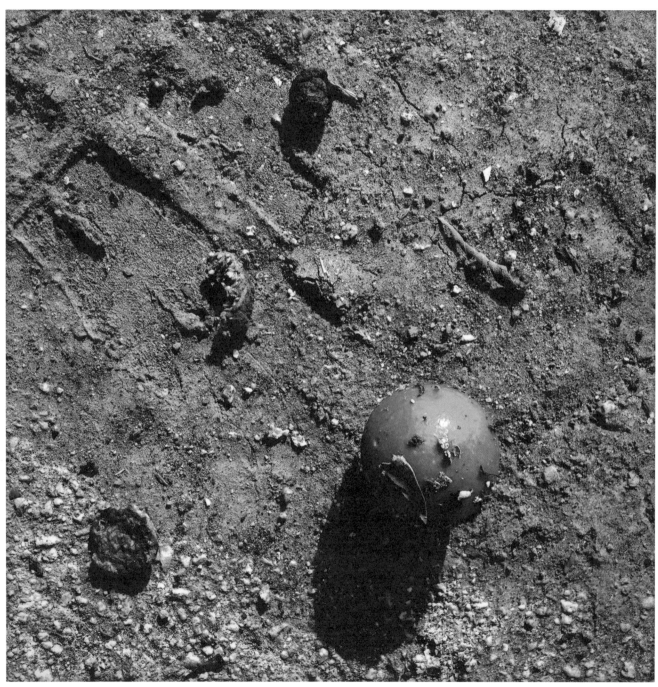

EARTH: An Insignificant Truth

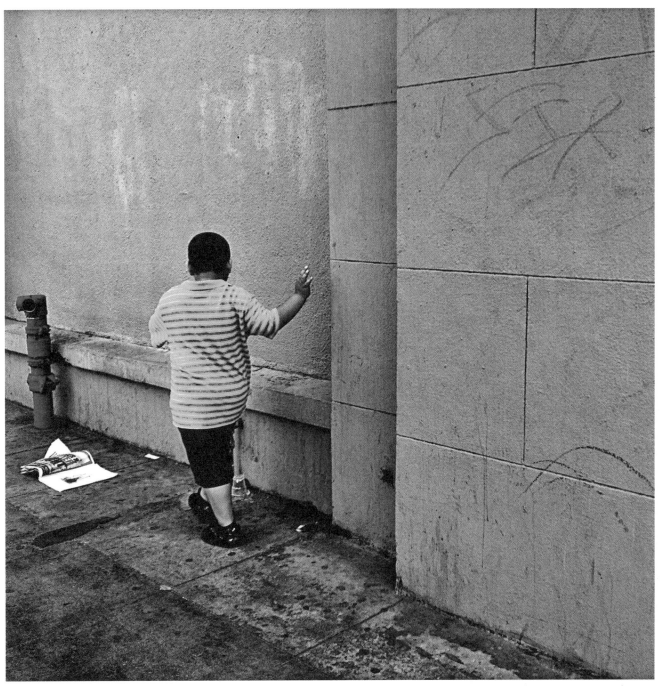

Kickin' It

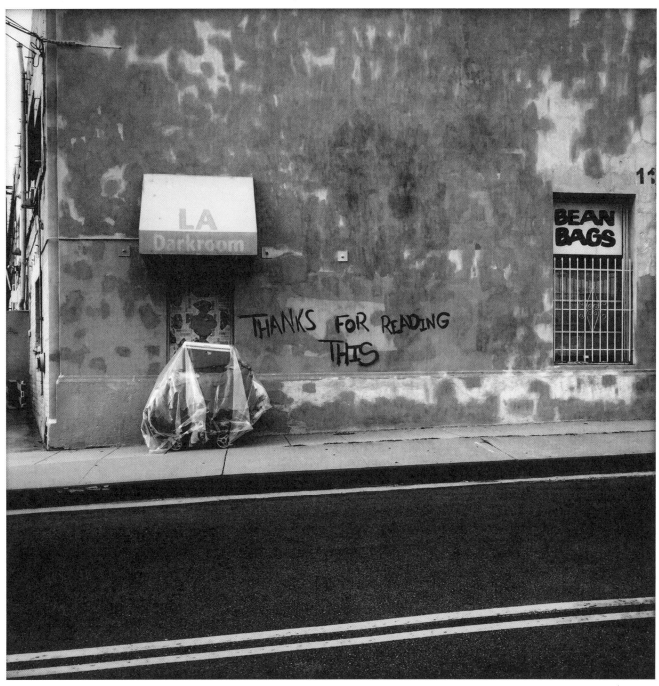

Gratitude Tag

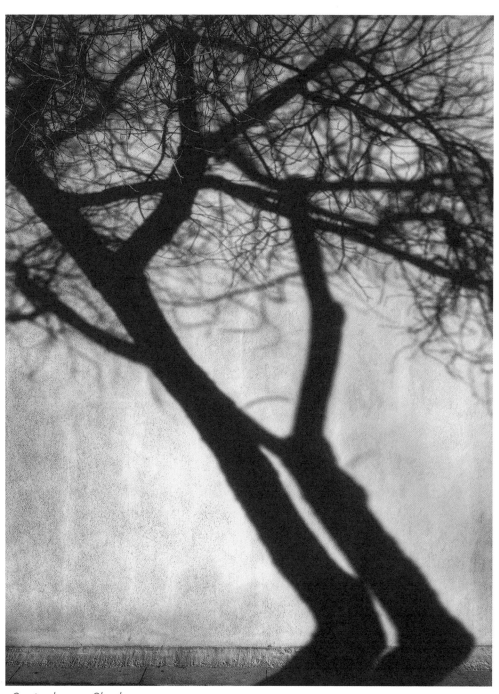

Cantankerous Shadow

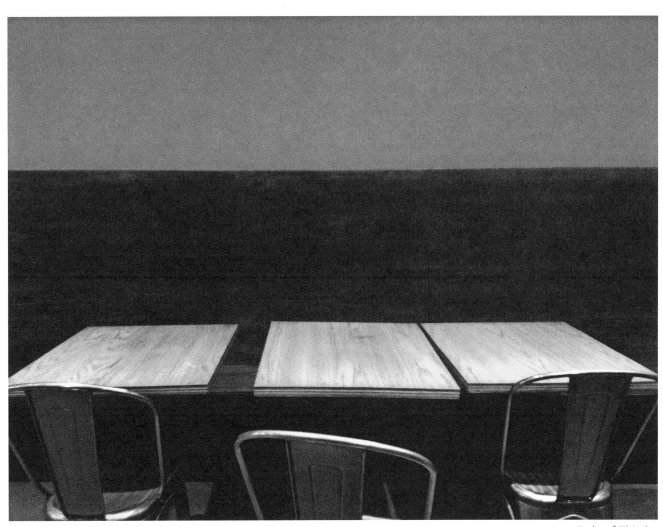

Rule of Thirds

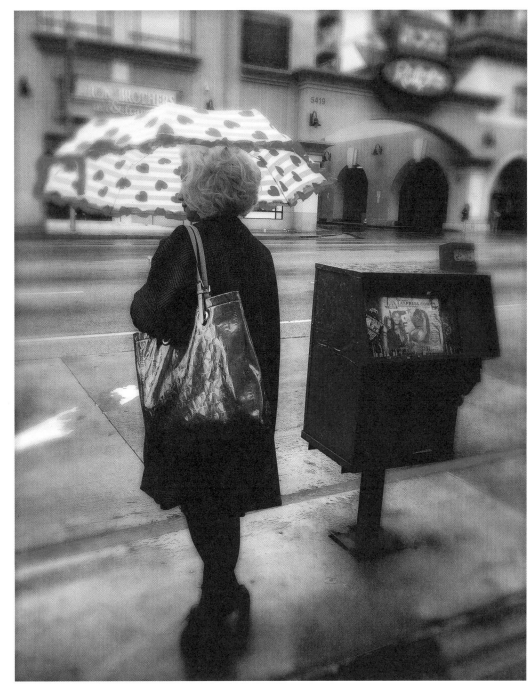

Showered with Love

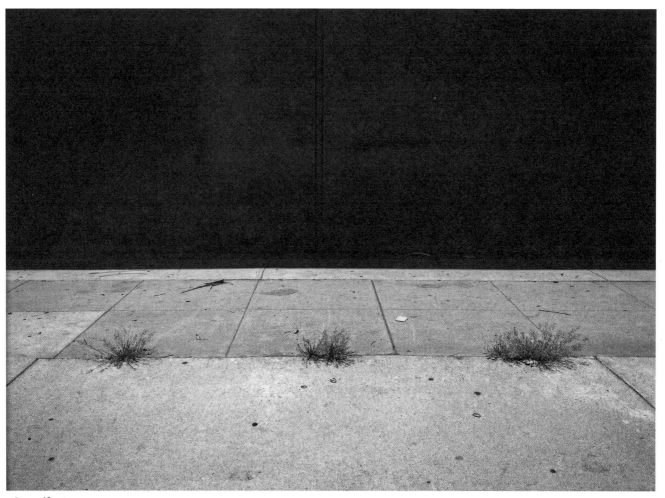

Steadfast

They saw it all. Heard unaccountable secrets muttered by each and every passerby. And kept it all to themselves.

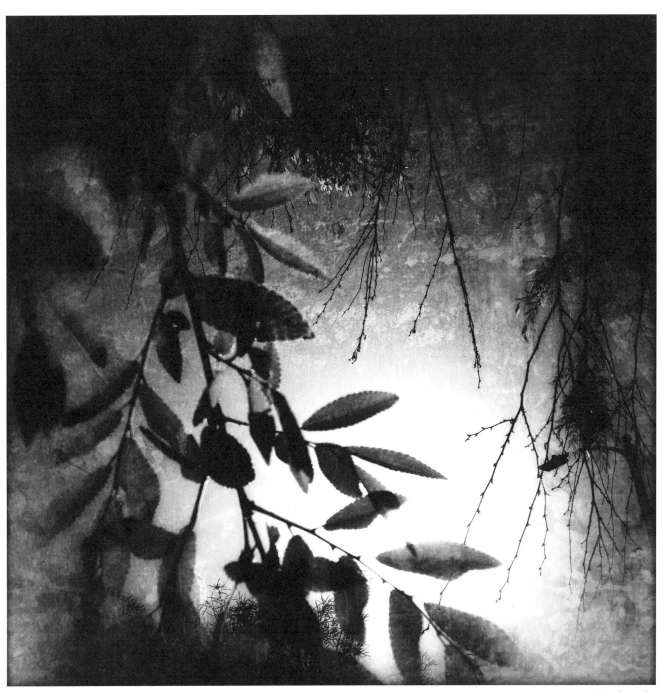

Daybreak

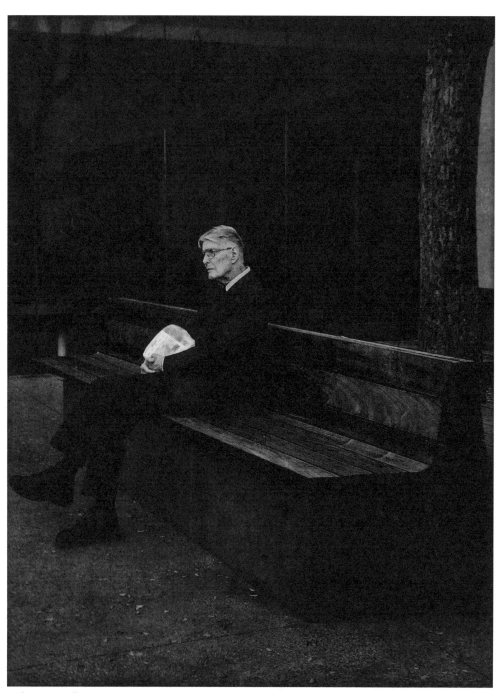

The Art Collector

Nathaniel has been careful all of his life. Hard work, good investments, a real commitment to his family and his mental and physical well-being. He is considered by all who know him a prudent and solid man.

But his weakness, the place inside his soul that craves passion and meaning, is insatiable. It is art that brings him alive. He can't make it; he's never been creative other than in his innate ability to make money grow.

He buys art, however, much to his wife and children's chagrin. But he's kept them well, so he figures in the cost of his joy. He knows when he passes on they will have a legacy far greater than they ever could imagine: the volatile impermanence of money will stand in stark contrast to the longevity of the toil of consciousness and the courage of eternal expression.

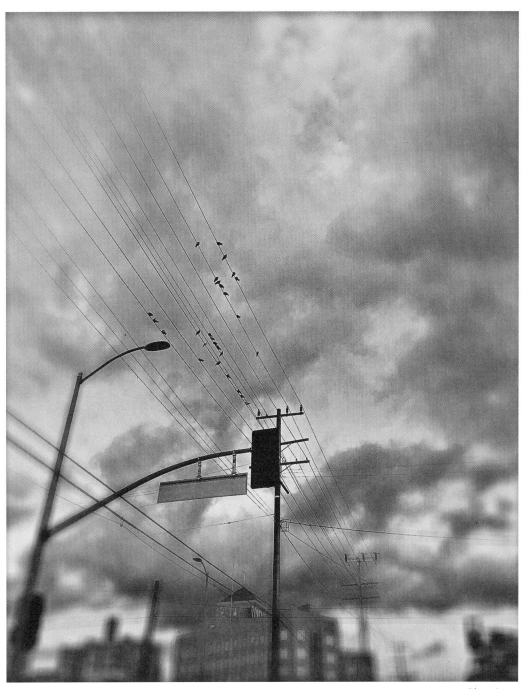

Clearing

Variations on a Pink Ribbon

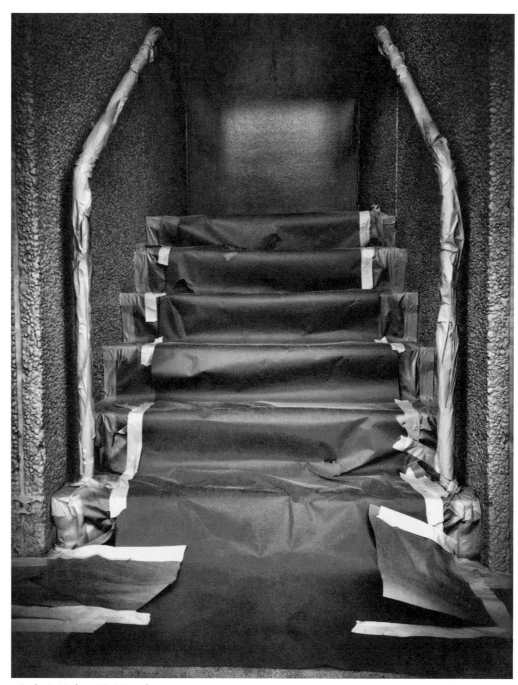

Ooh, It Makes Me Wonder

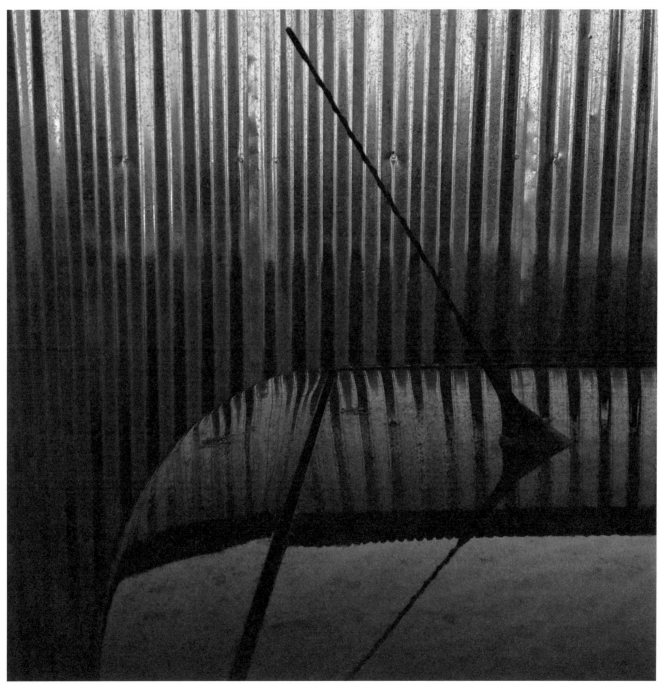

Receiver

Openness doesn't come from resisting our fears but rather from getting to know them well.

PEMA CHÖDRÖN

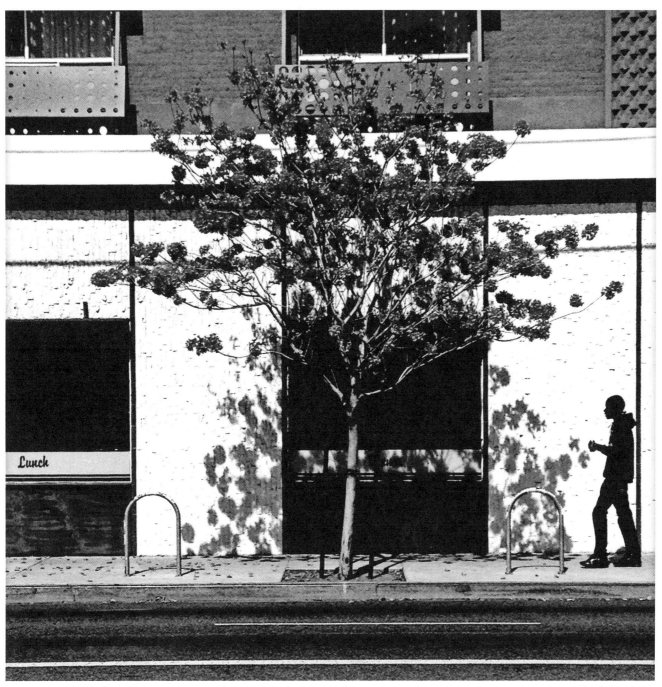

I See You

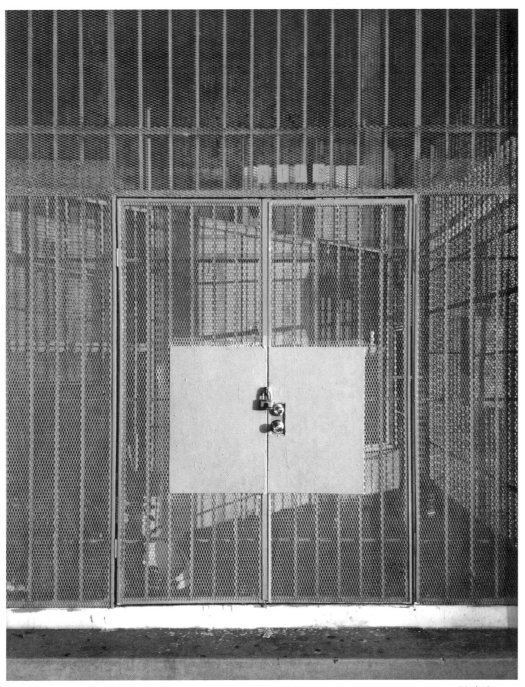

Pink Cage

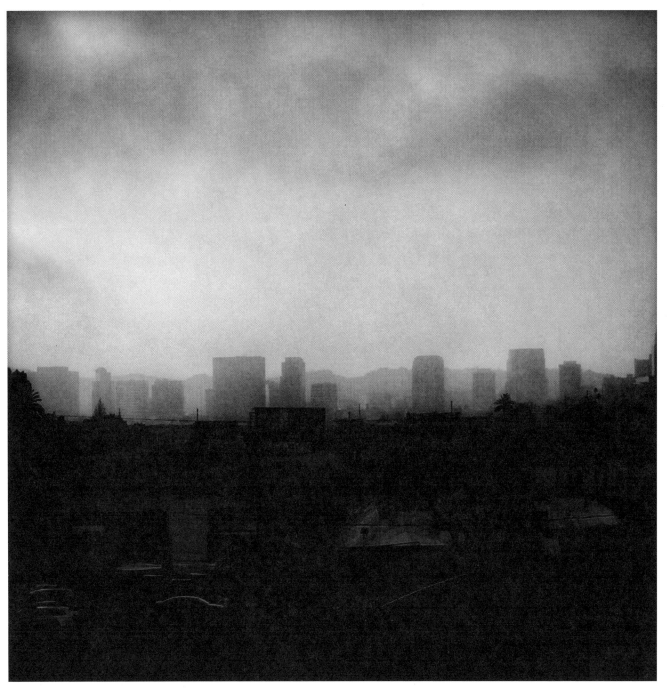

City Limits

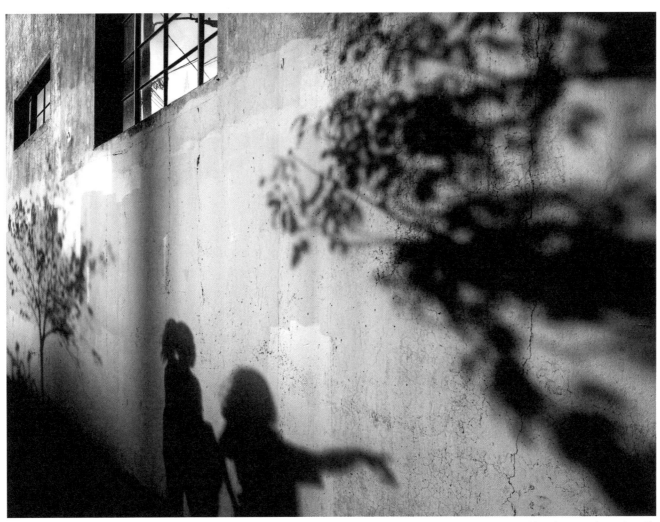

Shadows Take a Stroll

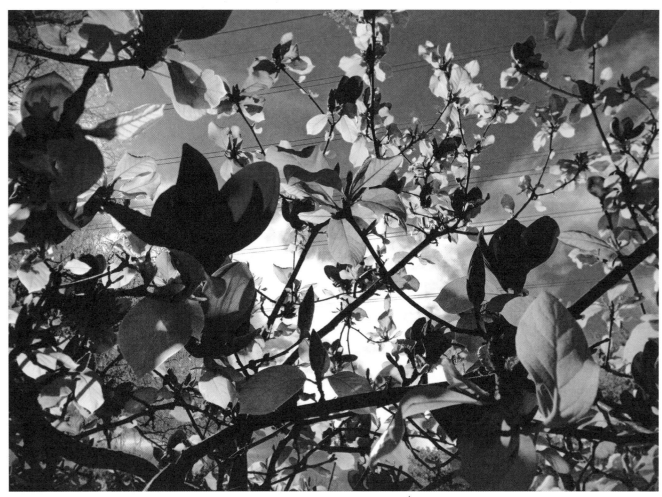

Good Fortune Branches Out

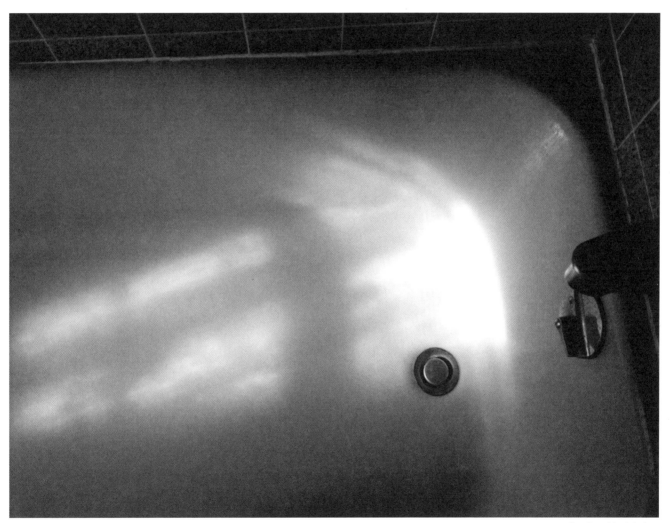

Bathed in Light

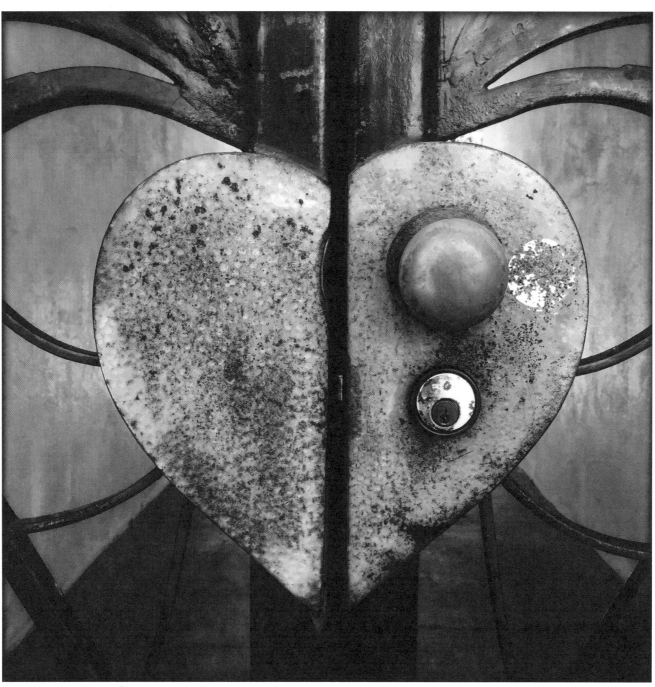

Open Door Policy

And the world cannot be discovered by a journey of miles,
no matter how long,
but only by a spiritual journey,
a journey of one inch,
very arduous and humbling and joyful,
by which we arrive at the ground at our feet,
and learn to be at home.

—WENDELL BERRY

RENEWAL

The family I hoped would love me didn't in the way I needed. This broke my heart for years, until I let it break me open. Hurt people hurt. The story cycle we get stuck in wears at us. Personal narrative matters; it moves us beyond familial identity. Contorting myself to fit the expectations of others, I made those around me comfortable at the expense of my own needs, constricting my view of myself and of the world. My dedicated photo-making practice showed me the value of reframing life. It emancipated me from the limited lens of my lineage. It reintroduced me to my authentic self.

My second course of chemotherapy wiped me out. Adriamycin and Cytoxan. My first course of chemo, twelve rounds of Taxol, and my lumpectomy had beaten me up; I figured this next phase of treatment couldn't be worse. Holy shit, I was wrong. Cancer circles refer to the A/C chemo-cocktail as the infamous "red devil;" the vile toxicity makes the side effects brutal. It makes you want to die. I lie in bed Savasana, barely moving, barely able to lift my head to sip water. Alone. Nothing can take away this suffering. With no spirit left in me to engage, I surrender and meet every cell as it dies off and let it go. Release the cancer, the pain, the disappointments, everything. The oblivion of sleep becomes my refuge.

I wake up the next day, hollow. I drag myself out of bed and draw a bath. I sit in the tub until the water becomes cold. My hands are shriveled and numb. I dry off and glance in the mirror. I look like my mother when she was dying. I turn away, afraid to see. I look again. I bring my face right up to the mirror. I'm astonished. I see little sprouts of lashes filling in around my bloodshot eyes. A faint line of eyebrows coming back. I thought I was meeting my death, but I am regenerating. This is one of the most profound moments of my life.

Love saturates the world. I found the simplest expressions of it in the damnedest places. Hidden in shadows patiently waiting to be revealed. In plain sight, brilliant in its familiarity. Shining through cracks and crevices, exposing hope and compassion. Our yearning to belong testifies to its potency. I saw how much I mattered to dear friends and my sangha. I felt the incredible kindness my health care team brought to my healing. I had meaningful exchange with my social network, and even perfect strangers on the street. It may not have been what I anticipated, but love is love. It emanated from me. How could I know the restraints of cancer would set me free? That ten miles would lead me to infinity? All it took was taming my mind, a clear heart, good medicine, and the receptiveness to be with it all.

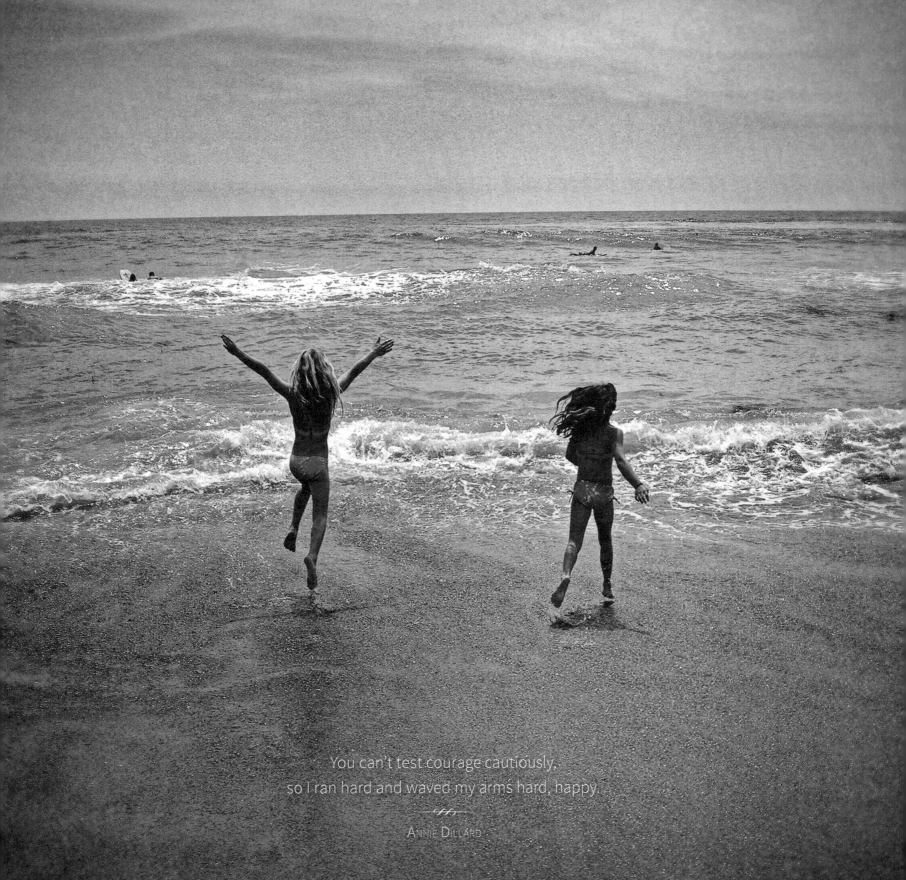

You can't test courage cautiously,
so I ran hard and waved my arms hard, happy.

— ✦ —

ANNIE DILLARD

GRATITUDE

Going through cancer is a tremendous undertaking and nearly impossible to do alone. These three fantastic women were my bedrock: Meredith Flynn, Stannie Ramsey, and Terri Hoyos—a pack of ferocious mama lions who looked out for my well-being and helped make this time in my life so much easier. I truly could not have done this without your guidance, love, and generosity. My deepest appreciation to you always.

Besides my pack of mama lions, there were many dear sidekicks on the Cat Chemo World Tour, wonderful friends who drove me to the hospital, picked up food and medicine, and shared their companionship and compassion on treatment or hydration days. Thank you Peter Schnaitmann, Raul Arauz, Iva Hladis, Judy Pokonosky, Larry Law, Andrea Herz-Payne, Michael Kirchoff, Aline Smithson, Ellen November, Melanie Maass, Alex Stein, Andrea Morris, and Tom Richmond. I felt all of your love.

I am incredibly fortunate to have many good friends and these lovely people helped me through my illness and back to health in a multitude of ways: Sebastian, Adam Kobrin, John Riehle, Geri Brostrom, Annie Segan, Noah Segan, Barbara Peacock, Mark Pellington, Lisa Ortiz, Julie Sommers, Jenn Miller, Shari Lee, Alison Cogan, Tabitha Fronk, Anne Duvally, Ben Hoffman, Gai Gherardi, Lisa Coburn, Amy Engelhardt, Susan Sisko Carter, Gerry Katzman, Rachel Toles, Sky Palkowitz, Janet Fitch, Rich and CLS Ferguson, Milo Martin, Miguel Sanchez, and my b/c-bff's: Jan Malanga and Char Hatch Langos. Special thanks to the glam squad who helped me sparkle throughout: Heba Thorisdottir, Jeri Baker, Lorraine Care, Penny Morse, iS Clinical, and Renata Helfman and the Lipstick Angels. I am grateful to you all.

To my collectively brilliant photo collective, the Six Shooters (sixshootersonline.com): Nancy Baron, Noelle Gilbert, Bootsy Holler, Heidi Lender, Eleonora Ronconi, Aline Smithson, and Ashly Stohl. Our daily photographic conversation truly helped keep me going. Thank you for the ongoing thread of visual connection.

To the many Facebook and Instagram friends who've been an elemental part of this experience with their affirming "likes" and thoughtful comments on my photographs; our connection truly sustained me. With special thanks to Jennifer Krentz and Wendy Hudgins, two FB friends whose luminous bandwidth far exceeds the internet.

To the Polymind Commune: your steady kindhearted support meant so much. Cancer has acutely impacted our circle; seven of us were inflicted in a matter of just a few years. We lost Taylor Negron and Karen Aschenbach, dear ones we will always miss. I especially want to acknowledge Christopher Allis and Garth Hammers, two friends who've been on the front line, not only with their wives going through cancer, but also right there with me on my own path. Thank you.

To my soul sisters the OG's (Original Goddesses…yeah, we're Gangsta's too): Rachel Allis, Kelly Carlin, Meredith Flynn, Theresa McKeown, and Amy Wieczorek. And to the other G's who are an intrinsic part of our sisterhood: Audrey Franks, Wendy Gladson, Wendy Hammers and Stannie Ramsey. You are generous, caring, hilarious, intelligent, spiritual seekers. It's a gift to share this amazing bond with all you nasty women.

To all the Radiant People who showed up and were open to being seen. The timing of your presence was auspicious. Our interchange touched my heart and helped me see more clearly. Namaste.

To all of the Against The Stream and Refuge Recovery sangha, a community of some of the finest people I know. With deep appreciation to Noah Levine, Josh Korda, Shannon Fowler, Curtis Washington, Gigi St. John, Josh Lichtman, Thomas Barnhill, Holly Brown, JoAnna Harper, and Mary Stancavage. And to my Refuge Recovery art students who were willing to mindfully meet their suffering with creative expression. *Be a light unto yourself.*

To my outstanding health care team at Cedars-Sinai Medical Center: Dr. Monica Mita, Dr. Armando Giuliano, Dr. Elizabeth Kim, Dr. Robert Katz, Dr. Arash Asher, Sherry Goldman, Bethany Wendel, Annette Sands, and Mary Rosenberg—my gratitude for your personalized expert care is beyond measure. To all the other good doctors, nurses, phlebotomists, imagining technicians, and Cedars-Sinai staff, your friendly professionalism truly makes the healing process so much easier. Additional thanks to Amara Yob for listening and making sure the process of my care went smoothly, and to Evelyn Zapanta, Novalyn Cruz, and Jerry Koontz for always making me laugh and feel so special.

To my other health care providers, healers, and therapists who helped me move though my illness and recover my life: Brent, Yuni and Ester, my considerate Hollywood Presbyterian radiation team who made this segment of treatment much more bearable. Dr. Michael Fox and Dr. Diane Sandler, your incredible bodywork is an integral part of my healing. Andrew DeAngelo and Harborside Health Center—many thanks for the therapeutic CBD oils. I am so fortunate to be a participant in the Cynvenio Biosystems Liquid Biopsy *ClearID Monitoring* TNBC clinical research study. And my heartfelt appreciation to Dr. Noa K. Hedaya for your wise guidance in helping me reframe my story.

The creative process to make and sell art is truly a collaborative effort and I am honored to work with people I admire and trust. Nancy Turner-Smith masterfully prints my images. I treasure the generosity of your artistry, intelligence, and our meaningful friendship. Glenn Friedman at Reclaimed Frame is an incredible craftsman and friend who exquisitely frames my artwork. Three bright colors caught the eye of my art dealer, Susan Spiritus, and connected us…that, and the solidarity of surviving breast cancer. Dylan Brody is the purveyor of fine words and phrases. You are a dear friend whose editorial finessing I greatly respect and helped make my story shine. Thank you. I could not have made a book this beautiful without my extraordinary graphic designer, Kathy Martens. You poured your heart into every page. Your dedication, thoughtfulness, and friendship mean so much. And finally, my sincerest regards to my publisher, Tyson Cornell, and the phenomenal team at Rare Bird: Julia Callahan, Hailie Johnson, Jake Levens, Gregory Henry, and Alice Marsh-Elmer. Thank you for supporting my vision of turning my story into a book and bringing it into the world.

Remnant of Momentary Pleasure

FIELD NOTES

I am a second-generation native Angeleno. I live in the Armenian flatlands of Los Feliz, right in between Barnsdall Art Park and the House of Pies. I was born at Glendale Memorial and my mom at Glendale Adventist, both mere miles from my home. All of the images I made in this book are roughly within a ten-mile radius of where I live, and a good portion were captured a mile or less from there.

My grandparents Robert and Helen Gwynn met in ninth grade, at the Sentous Intermediate School. It was located in midtown Los Angeles. In their yearbook is an essay my grandfather wrote, "When Los Angeles Belongs to Me." A graduate of UC Berkeley, he went on to become a structural engineer, and later a well-regarded California landscape painter. My grandmother graduated from Chouinard Art Institute and became an art teacher and a lifelong artist. They traveled the world, loved the outdoors, science, and culture. I continue to feel their positive influence in my life.

Going through my illness is helping me heal the bond with my mother, Connie Gwynn. She went to UC Berkeley and got her degree in anthropology, then years later her MFA in painting at Cal State Fullerton. My mom would have appreciated me using the backdrop of our natal home to excavate meaning and inform my narrative, transforming my experience with cancer into a work of art.

The technical aspects of this project are fairly simple. I shot these pictures over a three-year span—all through treatment and recovery—on an iPhone 4s for the first year or so, and then I upgraded to an iPhone 6. Some of the photos I left pretty much as is. Many of them were lightly processed, while others were run though numerous apps to create a look that felt suited to that particular image. What a joy to have so many options, and how fortunate to have turned a handheld device into a limitless foundation for mindful expression.

I'm partial to all the photos, but the moments of creation are what stick with me, each one a personal marker bearing the gift of another day. Another chance to see things more clearly and understand my place in the world. A time in my life when Los Angeles deeply belonged to me.

—Cat Gwynn

Photo by Lisa Orkin

CAT GWYNN was educated in photography, film, and fine arts at Otis-Parsons Art Institute, and has completed numerous master workshops with such esteemed artists as Mary Ellen Mark, Joel Peter Witkin, and Barbara Kruger. Her artwork is collected and exhibited in international galleries and museums including the Lishui Museum of Photography in China, The Drawing Center in New York City, the Orange County Center for Contemporary Art, and is sold through the Susan Spiritus Gallery. She has lectured at distinguished institutions including Otis College of Art and Design, New York University, and Art Center College of Design.

Cat's images have appeared on the cover of *Artweek* and in many other publications including *Artforum*, *Newsweek*, and *Texas Monthly*. She is also a seasoned lifestyle and portrait photographer whose images have sold through *Corbis* and *Getty Images* for nearly twenty years. Her commercial clients include Apple Computers, Starwood Resorts, Discovery Communications, and T-Mobile. In addition, Cat has gifted her talents photographing pediatric patients for Flashes of Hope, a volunteer organization focused solely on funding research for children's cancer.

Gathering the tools and techniques she discovered along her healing path, Cat developed *10-Mile Radius: Creating a Personal Map for Wellness*, a powerful transformative recovery program which marries art-making into a daily mindfulness practice. She teaches the program at recovery and wellness centers, working with patients to cofacilitate a shift in their personal narrative. The 10-Mile Radius program is being designed to expand into larger health care facilities.